P9-BZH-212

MODERN IMPRESSIONS

JAPANESE PRINTS FROM THE BERMAN AND CORAZZA COLLECTIONS
1950-1980

FRANK L. CHANCE

MATTHEW MIZENKO

PHILIP AND MURIEL BERMAN MUSEUM OF ART AT URSINUS COLLEGE

©2005 Philip and Muriel Berman Museum of Art at Ursinus College
601 E. Main Street, Collegeville, Pennsylvania 19426

This catalogue was prepared on the occasion of the exhibition,
Modern Impressions: Japanese Prints from the Berman and Corazza Collections, 1950-1980,
which was presented at the Philip and Muriel Berman Museum of Art at Ursinus College
from February 15 to April 10, 2005.

Essay Pages 5-8 ©Frank L. Chance and Matthew Mizenko,
Pages 9-12 ©Matthew Mizenko, and Essay Pages 13-15 ©Frank L. Chance
Checklist of Works in the Exhibition Pages 81-94 ©Frank L. Chance and Matthew Mizenko

Photography by Greg Benson
Design by Julianne Domm
Printed in Iceland by Oddi Printing

This publication is typeset in Avenir and printed on Munken Lynx paper.

No part of this book may be reproduced or transmitted in any form, including photocopying, recording,
facsimile, or by any storage or retrieval system, without written permission of the
Philip and Muriel Berman Museum of Art at Ursinus College.

ISBN 1-889136-18-2

Distributed by
Art Media Resources, Inc.
1507 South Michigan Avenue
Chicago, Illinois 60605
www.artmediaresources.com

Exhibition, Catalogue, and Programs funded by a grant from the Freeman Foundation

COVER IMAGE:
Saitō Kiyoshi (1907-1999), *Chinese Temple Nagasaki* (detail)
Woodblock print, 1955, Numbered 37/40
20 1/4 x 32" (image)
Promised gift of the Philip and Muriel Berman Foundation
Catalogue Number 15

FOREWORD

The core of the collection of modern Japanese woodblock print impressions in the permanent collection of the Philip and Muriel Berman Museum of Art was established by Philip and Muriel Berman in the late 1960's with a gift of works by Onchi Kōshirō, Azechi Umetarō, Inagaki Tomoo, and Saitō Kiyoshi. Another 40 prints by various artists were added to the collection over the years, including significant images that focus on the career of Saitō, one of the better-known artists of this genre.

The prints have been enjoyed and exhibited sporadically; however, they had never been studied and interpreted in depth. The growth of the Ursinus College East Asian Studies program brought renewed focus on these images as a component of the teaching and research goals articulated by both the department and the museum.

In 2001 the East Asian Studies program, under the leadership of Hugh Clark, professor of history, received a prestigious Freeman Foundation grant that provided resources for important curricular initiatives, scholarly collaborations, additional faculty, and the opportunity to develop an exhibition based on the museum's Japanese print holdings. This component of the grant also enabled museum staff to engage students in the process of developing interpretive programs that would reach their peers. Matthew Mizenko, assistant professor of Japanese and East Asian Studies at Ursinus College, agreed to curate the exhibition and he recruited his colleague, Frank L. Chance, associate director of the Center for East Asian Studies, University of Pennsylvania, to co-curate the installation.

There is a lot of give and take when a curatorial team takes on the challenge of developing a cohesive exhibition theme, selecting appropriate images and objects, and conducting extensive research on both the artists and the compositional content of the work. There was fluidity in the way that Dr. Mizenko and Dr. Chance worked together that has resulted in both a superb installation and this important catalogue that includes high quality scholarship and extensive documentation of the museum's holdings.

As the curators began their assessment of the museum's collections, certain gaps emerged that would necessitate seeking external loans to maintain a cohesive flow to their investigation of modern Japanese printmaking, specifically between 1950 and 1980. Parallel to their work, I had been introduced to alumnus Dr. Leo J. Corazza '45 by board member Llewellyn Dryfoos '59. Dr. Corazza actively collected modern Japanese impressions throughout his years in the military, based in Japan and Korea, and during his long medical practice. He was interested in sharing this collection with his alma mater if it would fit with our mission. Dr. Mizenko and Dr. Chance subsequently visited with Dr. Corazza and found not only that his collecting interests mirrored those of the Bermans, but that his collection contained additional important examples that would complete their thesis for the exhibition.

The curators returned home with a wealth of material and between the two collections developed a vibrant and cogent examination of the genesis and evolution of the modern Japanese woodblock print. Because of their work, and the importance of the Corazza pieces in the context of the museum's collecting mission and the Ursinus College curricular goals, Dr. Corazza made a formal gift of his collection, numbering over 200 impressions, to the Berman Museum of Art. We thank him for being an enthusiastic partner in the development of this exhibition and for the generous donation of his fine collection.

We gratefully acknowledge the support of the Freeman Foundation for underwriting the exhibition, catalogue, and programming associated with the installation. Many participated in the logistics of implementing the curatorial vision and the curators and I extend our thanks to Suzanne Calvin, administrative assistant, Susan Shifrin, Associate Director of Education, Gary White, our one-person installation crew, the student staff of the Berman Museum of Art, and the staff of Ursinus College, along with Christopher Eames of Frameography, Greg Benson of Greg Benson Photography, Julianne Domm and Chuck Gershwin, who are responsible for the design and production of this catalogue, and Ted Xaras, Professor of Studio Art at Ursinus College, for their collective energy and talent. Professor Xaras' students contributed woodblock prints to a historical and contextual gallery associated with *Modern Impressions*. Other lenders included Frank and Linda Chance, Andrea Cooper and Matthew Mizenko, and Haruko and Albert Mizenko.

The curators wish to thank Linda Chance and Andrea Cooper for the many ways in which they contributed to this project. The curators are also indebted to the University of Pennsylvania's Center for East Asian Studies, and to its Director, G. Cameron Hurst III, for their generous support. Dr. Mizenko's participation in this project was made possible by the Faculty Early Leave Program of Ursinus College.

Lisa Tremper Hanover
Director
Philip and Muriel Berman Museum of Art
at Ursinus College

JAPANESE PRINTMAKING:
A SHORT HISTORY

FRANK L. CHANCE AND MATTHEW MIZENKO

The oldest known prints made in Japan were rubbings taken from carved stones in the sixth century. Soon after, the technique of printing text from woodblocks was imported from China by way of Korea. In around the year 770, a massive project was undertaken called the *hyakumantō darani* or "One Million Pagoda Prayers," in which ritual formulas were printed on slips of paper that were rolled up and placed in thousands of miniature wooden pagodas. Other early prints were made of Buddhist images, including guardian figures that could be placed in amulets worn by believers for spiritual protection. Larger prints reproduced the images of Buddhist deities and guardians for display and veneration.

For hundreds of years, however, the main use of printmaking in Japan was to reproduce texts. These included Buddhist *sūtras*, Confucian ethical treatises, and only much later works of poetry and fiction. Around 1640, illustrations began to be included in woodblock printed books, growing more prominent until the appearance, about 1660, of independent pictorial prints (*ichimaie* "single-sheet pictures"). Soon after, printmakers such as Hishikawa Moronobu (c. 1618-1694) began to include signatures. Moronobu was also one of the first artists to produce sets of pictures contained in an album or folder, like Tokuriki's *New Eight Views of Omi* (Exhibition #12).

Moronobu and other printmakers of the seventeenth and early eighteenth century worked in monochrome, though colors were often added to their prints by hand. Subjects of the early prints were beautiful women and handsome men – courtesans, dandies, and actors in the *kabuki* theater, said to inhabit the *ukiyo*, or "floating world," a demimonde funded by prostitution and fueled by ever-changing fads in fashion, fabric, and flirtation. The prints illustrating this world came to be known as *ukiyoe*, "pictures of the floating world," and joined fully in the race to be up-to-date not only by depicting the latest hairstyles and kimono patterns but also by continually upgrading their printmaking technology.

By about 1700, publishers added professional colorists to their stables of block-cutters and printers, and the government began to require the publisher and the print designer to identify themselves within the print. Artists began to specialize – Kaigetsudō Ando (1671-1743?) for example, made only images of beautiful women, while the Torii family, beginning with Kiyonobu (1664-1729), worked almost exclusively on *kabuki* actor portraits. Hand coloring became more elaborate with the addition of imitation lacquer and the inclusion of metallic gold, silver, and copper to create opulent surfaces. Around 1730, Okumura Masanobu (1686-1764) began to experiment with color printing by using a second block to place red or green onto the image as well. This set the stage for the great technological leap into full-color printmaking.

In 1764, under the sponsorship of Kikurensha Kyosen (1722-1777), Suzuki Harunobu (1724-1770) developed accurate methods of registration that allowed more color blocks to be used on a single print. Often employing ten or more blocks, these multi-color prints came to be known as *nishikie* or "brocade prints" from the complex interweaving of colors and patterns that imitated the elaborate textiles popular at the time. From this point on, the history of Japanese printmaking becomes primarily one of stylistic development rather than technical improvement.

Prints of Harunobu, Torii Kiyonaga (1752-1815), and Kitagawa Utamaro (1754-1806) epitomize the changes in style that swept through early modern Japan. Harunobu's figures are slender, childlike waifs of the 1760's; Kiyonaga's are tall and elegant adults of the 1780's. Utamaro's women are robust and powerful, sexy but full of attitude, strong and willful despite objectification. Katsukawa Shunshō (1726-1793) and Tōshūsai Sharaku (active 1794-95) traced similar patterns of changing popularity among the *kabuki* actors of these same decades. With other printmakers of the day, these masters give us a powerful visual impression of their times.

Beginning in the 1830's, imports of strongly colored chemical dyes began to transform the palette of inks available to Japanese printmakers. The first of these dyes, which came primarily from England, were clear, saturated blues; later yellow, green, purple, and red inks were also made chemically. As their harsh colors replaced the gentle harmony of vegetable dyes, a new subject – landscape – also came to the fore in the prints of Katsushika Hokusai (1760-1849) and Andō Hiroshige (1791-1858), while other printmakers continued to produce pictures of beautiful women and kabuki actors. The most prolific artists, Utagawa Toyokuni (1761-1825) and his pupils Kunisada (1786-1865) and Kuniyoshi (1797-1861) worked in all genres, making prints of landscapes, women, and actors, to produce thousands of vivid representations.

When the ruling Tokugawa family lost power in 1868 and the Meiji Emperor (1853-1912) took nominal control, Japan moved toward a modern, more Western mode in clothing and aesthetic matters as well. Woodblock prints came to be regarded as an effective means of propaganda for the modern, emperor-centered state. Prints by artists such as Toyohara Chikanobu (1838-1912) constructed an image of the emperor as a virile, active, protective and caring father figure in the imperial family, and by extension, for the family of the nation. Once the emperor was firmly established in this role, he was no longer depicted in prints, returning to his traditional location "above the clouds."

Woodblock prints were published to celebrate Japan's urbanization, industrialization, and militarization. But other printmaking methods – engraving, etching, and lithography – eventually led to the decline of *nishikie* in the popular market. In the opening years of the twentieth century, most woodblock publishers closed up their shops entirely. The medium survived by turning to an elitist art market for its economic base.

The term *shin hanga*, usually translated as "new prints," describes a movement of artists who wished to revitalize the Japanese woodblock printing tradition that had stagnated in the early 20th century. At this time, publishers, who were in total control of the printmaking process, had their artisans produce endless editions of reproductions of classic *ukiyoe* prints by such masters as Utamaro. The *shin hanga* artists sought to bring a more contemporary subject matter to the prints, often depicting landscapes populated with automobiles and people in Western dress. This movement differs from the later *sōsaku hanga* movement in that it still utilized the collaborative system of printmaking, in which prints were produced by a publisher and artist working with a team of artisans. Among the most famous artists of this school were Itō Shinsui (1898-1972), Kawase Hasui (1882-1957) and Yoshida Hiroshi (1876-1950). Another way in which these artists differed from the *sōsaku hanga* school is that they were primarily identified as painters or watercolorists, while the *sōsaku hanga* artists specialized in printmaking.

The term *sōsaku hanga* is usually translated as "creative print." It was devised to describe an approach to printmaking that differed from the collaborative approach that had dominated until then, in which a publisher and artist, along with carvers and inkers, would make prints. Instead, the *sōsaku hanga* artist designed the print, carved the block, and then inked the paper. The *Sōsaku Hanga Kyōkai* (Creative Print Association) was founded in 1918, but the movement did not achieve its full potential until after 1945, when the prints found favor among foreigners involved with the Occupation. As a result of the efforts of such patrons as Oliver Statler and James Michener, who both wrote influential books on the movement, *sōsaku hanga* became collected outside Japan, and the printmakers won awards at prestigious international

competitions. Among the artists recognized as leaders of the movement are Onchi Kōshirō (1891-1955) and Hiratsuka Un'ichi (1895-1977), both of whom are represented in this exhibition. Many prints, notably those by Saitō Kiyoshi (1907-1999), came with a label reading "Self-carved Self-printed," to indicate their authenticity as *sōsaku hanga*.

Saitō, in fact, may be regarded as the epitome of the professional *sōsaku hanga* artist. Artists such as Onchi had seen prints as works in progress. Editions often were not limited in advance, and different impressions were sometimes inked differently. Saitō promoted the movement's motto relentlessly, he was extremely careful in titling and numbering his prints, and unlike many other print artists, he signed his works prominently, often in ink, in the image – as much in imitation of the conventions of modern oil paintings as of traditional Japanese woodblocks. He marked his prints with his seal on both the front and the back, and he even used his name as a watermark on his paper. Saitō's period of greatest creativity, well represented in this exhibition, coincided with what is generally considered the peak of the postwar *sōsaku hanga* movement – that is, from the 1950's into the early 1960's. By the 1970's, as younger artists worked more widely in techniques other than woodblock, the *sōsaku hanga* movement was no longer dominant in Japanese printmaking circles.

Whereas *shin hanga* tended to maintain the style of ukiyoe while updating the content with depictions of contemporary life, the *sōsaku hanga* artists sought to modernize the form as well as the content of prints. Many artists specialized in abstractions, or brought an element of non-objective style even to otherwise representational pieces. In *Snow Scene* (37), by Kitaoka Fumio (b. 1918), most of the image is a reasonably traditional landscape, but the swirling calligraphic forms in the lower right section are nearly as intense as an abstract expressionist painting. The works in the exhibition give insight into the broad range of formal approaches utilized by postwar print artists.

Given the modernity – and even experimentalism – of form, however, the content of the prints in this exhibition tends to be conservatively "traditional," or safely abstract. In the aftermath of war, most Japanese print artists appeal to the modernist or Orientalist tastes of their patrons, providing either abstractions, or imagery taken from Japanese religious and historical culture, landscape, and its adorable animal companions. To a great extent, any evidence of the economic, social, and political upheaval of Japan from 1950 to 1980 is discerned either in its absence, or hidden below the surface.

Today, Japanese printmaking remains a lively sector of the art scene both internationally and at home. Woodblock prints produced by such Japanese artists as Kurosaki Akira (b. 1937) are modernist masterworks, while American Clifton Karhu (b. 1927) creates traditional imagery – often centered on the houses and cityscapes of Kyoto, where he has made his home for half a century. Oda Mayumi (b. 1941) is a Japanese-born painter and printmaker who lives and works in Hawaii; her works combine a feminist sensibility with forms inspired by such sources as Chinese poetry, Japanese Buddhist images, and Pop Art of the American twentieth century. Kataoka Tamako (b. 1905) continues to live and work in Japan, drawing her inspiration from her native land to produce brilliant images of Mt. Fuji in paintings, woodblock prints, screen prints, and lithographs; she has also often produced portraits of the great Japanese printmakers of the past, from Hokusai and Hiroshige to Munakata and Onchi.

Tanaka Ryōhei (b.1933) is recognized as one of the world's best creators of etchings for his images of farmhouses and other buildings of the Japanese countryside. Wakō Shuji (b. 1931) is equally world-renowned as a lithographer; though he produces relatively few editions (about 8-10 per year) they are exquisitely crafted visions of silk thread balls, folded paper cranes, and similar toys. In short, we can conclude that printmaking of all types is alive and well in Japan, and continues to be exported from there throughout the world.

This exhibition features 64 prints by 35 artists active in the third quarter of the twentieth century. Their mastery of printmaking techniques is remarkable, from the single woodblock of Hiratsuka's *Usuki Buddha* (4) to the richly inked layering of Maruyama's *Round About Midnight* (64). Though most of these prints are color woodblocks, other media include stencils (6, 33, 34, 35), etchings (40, 52, 54) one lithograph (63) and a screen print (42). The range of subjects is similarly broad, from pets (10, 11, 13) and people (2, 36) to poems (43-45) and pure abstractions (5, 60). Despite the breadth of the two collections merging to form this show, strong patterns of style can be traced across the entire group. A fascination with, as Leo Corazza put it, "strong colors and bold lines" is evident throughout the body of works included here, and equally among the other prints in the Berman and Corazza collections that could not be included. We hope you will enjoy viewing them as deeply as we enjoyed choosing and preparing them for exhibition.

THE LIMINAL SPACE OF *SŌSAKU HANGA*

Matthew Mizenko

The narrative of the *sōsaku hanga* artists may be one of liminality: of in-betweenness and ambiguity, of being situated at a threshold. These artists occupied a fluid and somewhat nebulous space between traditional Japanese art and modern Western art, traditional Japanese printmaking techniques and methods and those of the West, collective and individualistic social ideologies, Japanese nationalism and an emergent globalism, Japanese and foreign subject matter, prewar and postwar images, "high" art and "low" art, elitist patronage and mass-marketing, and figurative and abstract style. If we were to indulge in the Orientalist and slightly condescending representation of Japan as a place where tradition and modernity meet, as if this happens in no other country, then this narrative would seem to supply evidence for that image. But it would be vastly more fruitful to venture a nuanced and complex approach that would not reify binarisms of "tradition" and "modernity," or "Japan" and "West," seeing Japan as little more than an intersection of two different trajectories, but rather seek to understand the variety of social, political, economic and cultural forces at work on art and artists in general, and then to look at how these forces mesh together within the specifics of the particularity we are calling Japan. Such specifics include the influence of the political turmoil of the prewar period; the effect of Japanese militarism and nationalism in the 1930's and early 1940's; the consequences of Japan's devastation, defeat and reconstruction; the cultural and economic impact of foreigners in Japan during the Occupation, who were looking for souvenirs and art objects; and even the effect of the exchange rate, which made Japanese products so affordable to foreigners (including those who, like Leo Corazza, bought their prints through catalogs and consignment shipments from such dealers as the Red Lantern Shop of Kyoto). It would also be prudent to keep in mind the realities of cultural imperialism – that is, the overwhelming power of Western culture outside the West, where such power must elicit a response that is situated along a continuum ranging from a full embrace to a hostile reaction, and where in any case artists often strive to gain the recognition of the West, and thereby a sense of legitimacy.[1] It is no surprise that Saitō Kiyoshi's winning of a first prize at the 1951 Sao Paolo Biennial is considered to be a watershed moment in the history of *sōsaku hanga*.

The generous, albeit Orientalist, spirit of such figures as Oliver Statler and James Michener in the early postwar years was also a contributing factor to the success of Japanese printmakers after the war. In Japan for the Occupation, they were disposed to play a part in the rehabilitation of Japan's image from that of the vicious, treacherous, squinty-eyed and buck-toothed caricatures seen in American propaganda during the war, to a representation of the Japanese as exquisite, cultured, inscrutable and gentle (and with regard to the men, somewhat effeminate – that is to say, in a sense emasculated and non-threatening). It is quite astonishing how quickly this representational shift was implemented. It may have reached its climax with the release in 1957 of the film, *Sayonara*, based on James Michener's 1954 novel of the same title. The movie was almost a travelogue of all the now-clichéd highlights of Japanese culture, laced with a solemn condemnation of anti-Japanese racism. The date of the film's release coincides with the period that many observers have called the peak of the postwar *sōsaku hanga* movement, from the 1950's into the early 1960's. It may be more than a coincidence that Saitō and Munakata Shikō were racking up international awards with bodies of work that centered on peaceful, meditative, and transcendental Buddhist imagery.

The artists' gesture of inhabiting an interstitial space goes back to the origins of *sōsaku hanga*. This movement has been traced by Helen Merritt to 1904, when Yamamoto Hanae, who had been trained not as an artist but as a wood-

engraver, published the print, *Fisherman*. Yamamoto carved and printed this work himself, influenced by the methods of European printmakers. His friend, Ishii Hakutei, a lithographer with the government and a writer on art, published an article claiming that Yamamoto's print was revolutionary because it violated the tradition of producing prints collectively, with the involvement of the artist, publisher, and artisans. On the other hand, it transgressed Western practice in using the traditional Japanese cherry-wood board with the grain, rather than an end-grain block. Not only the technique, but the subject matter as well was claimed to be radical by Ishii, in that Yamamoto had depicted a contemporary and original subject instead of adhering to the practice of making reproductions of *ukiyo-e*.[2]

It is significant that Ishii noted two forms of transgression – against both Japanese and Western practice – in this one tiny print. This quality is emblematic of the balancing art performed by *sōsaku hanga* artists for the duration of the movement, as they sought to "modernize" a most Japanese art form of woodblock prints (recognized as such in the West, even if it took a long time to be considered "art" in Japanese circles). Indeed, much in the spirit of the "modernist" movement, the artists were both conservative and radical. If many Western modernists were cultivating the idea of the creative genius as they were rebelling against the growth of a capitalist, consumption-based economy and the mass culture that it produced, then Japanese *sōsaku hanga* artists were fighting traditional techniques of print production by seeking to remove the artist from a corporate structure in favor of the atelier of an individualist. It is not surprising that this movement emerged in a time of great debate in Japan as to the direction of its social structure.

The history of the first decades of the *sōsaku hanga* movement is one of a search for legitimacy, as it sought recognition alongside the "fine arts" of painting, calligraphy, and sculpture in the curriculum of arts schools and in the group exhibitions that dominated the art world. The artists, who mobilized themselves by creating organizations and holding exhibitions, met with some, albeit limited, success, including the incorporation of printmaking into the curriculum of the Tokyo School of Fine Arts.

After Japan's surrender, as most of the large cities of Japan lay in ruins, *sōsaku hanga* artists quickly organized to mourn Japan's cultural losses while regrouping in order to carry the movement forward. In December 1945, a set of fifteen prints was published by the Nihon Hanga Kyōkai (Japan Print Association), titled *Recollections of Tokyo*. The intention of the set was to "commemorate some of the features of Tokyo which have now disappeared," according to a statement that accompanied the prints. The statement began by mourning the destruction of major historical landmarks of the city, noting that "as we stand in the midst of this devastation, we are silent because our feelings are inexpressible." But the statement concludes on a positive note: "Japan is now well on the way to reconstruction. We are pleased that we are able, by the publication of this set of prints, to make an artistic contribution to our land."[3]

A similar expression of loss was produced by Onchi Kōshirō in his print, *Violinist* (2), and the accompanying poem, which is reproduced in the checklist. The profound sadness in Onchi's image and words may hold within it the key for survival, which was to move beyond such feeling and to construct a new nationalist spirit that would be palatable to the West. In a postwar work, Kawabata Yasunari, the novelist, paraphrased a Chinese poet: "the country defeated, the mountains and rivers remain." The artists were to find their theme in commemorating what remained, not in mourning what had been lost. Their project was to contemplate, and in a sense, market, what still existed of an idea of Japan. We search in vain for images of the Atomic Dome in Hiroshima, or the new shipbuilding plants, or the office buildings of Tokyo. We do not find signs of the emerging consumer culture, or of the political turmoil of the times.

That said, the best of the early postwar prints present impressive technical gestures even within the limits of their vocabulary of images. One of the most notable of these gestures was made by Saitō Kiyoshi, whose mature work is well represented in this exhibition. Earlier work by Saitō, not included here, included quaint depictions of villages populated with typical inhabitants, done in a style that incorporated a sense of three-dimensionality, or as Statler calls

it, "realism."[4] But in most of the pieces in this show, Saitō took his temples and gardens and the like, and radically flattened them out.

In making this gesture, Saitō reinterprets nostalgic images in a new idiom that is a stylistic pastiche incorporating elements of modernism and of "traditional" Japanese two-dimensionality. Features of architecture and plant life are not only flattened, but also reduced to large swaths of color that tip towards abstraction. Most importantly, the illusion of depth, and the associated control of the viewer's field of vision, is consciously abandoned. Two slightly different approaches can be discerned in the prints. A full-scale flattening of the image can be found in *Syoji Katsura Kyoto* (14) and *Shoji Sanpo-in Kyoto* (25). Merritt notes that Saitō is said to have been inspired by Mondrian in these prints. She writes,

> In 1954 on a visit to Katsura palace in Kyoto he discovered the orderly beauty
> of architecture and compared it to the intellectual organization he had seen in
> Mondrian paintings. This led him to search for the essentials of nature and express
> them in flat areas of color and texture in bold and graceful designs.[5]

It appears, however, that something else is going on as well, as Saitō transposes Mondrian's abstract style onto representations of Japanese buildings and gardens. By flattening out his images and rejecting the hierarchical ideology of depth, Saitō allows the viewer to explore the visual plane freely, while also making the point that no aspect of the image is necessarily more significant than any other. His gesture becomes even more radical in such prints as *Katsura Kyoto* (16), *Moss Garden Saiho-ji Kyoto* (21), and *Garden Sendogosyo Kyoto* (22), in which the flatness of the two previously cited prints is made more complex by creating visual lines that move the eyes in spatially contradictory ways, essentially incorporating multiple angles of perspective into the print, but in a way that appears to be different from that of cubism. The ultimate effect in these last three prints is to quote Japanese "traditional culture" while at the same time stripping it of its historical content. Herein lies the ambivalence and paradox of postwar Japan and its print artists: in their attempt to recuperate Japanese "tradition" in the aftermath of the war and in the context of a radically changing society, they are forced to acknowledge that that there has been a rift with this "tradition," which is now a signifier of an imagined self-identity that has been "lost," an "Orient" that is being constructed for the consumption of international collectors. It is noteworthy that the two Saitō Buddhas in the exhibition, along with the Egyptian figure, have been decontextualized and flattened to the extent that they are markers of ideas as much as representations of sculptures. This becomes even clearer when these prints are compared to Hiratsuka Un'ichi's *Usuki Buddha*, which places the Buddha heads in a recognizable context.

The contemporary Japanese artist Murakami Takashi has created a term, *Superflat*, to describe a not-unrelated phenomenon of the culture of Japanese animation, or *anime*. He discusses the imagery of *anime* as rejecting the concept of "depth" in both pictorial and ideological terms. Visually, the images embrace two-dimensionality and reject any attempt to create an illusion of three-dimensionality or depth. Murakami cites earlier Japanese art in which different images coexist equally and the viewer's eye is free from the constraints of perspective. In the contemporary world, such "flatness" also comes to reproduce the "flatness" of contemporary culture that, in a rejection of hierarchical ordering, allows "high" and "low," "Japanese" and "non-Japanese" culture to coexist in the same flattened postmodern space.[6] Saitō's prints may be seen as a reflection of the visual qualities noted by Murakami, and as perhaps a precursor of the sociocultural phenomenon he identifies. This kind of flatness can be seen in another print in the exhibition: *Tea Stall at Miidera* by Kitaoka Fumio (38). Visually, the print is more "traditional" than Saitō's, but the content constitutes a flattening of "traditional" and contemporary signifiers, with such elements as the banner advertising "Fujicolor" coexisting in the same plane as the old structures of a temple that has been a pilgrimage site for a thousand years.

To identify *sōsaku hanga* in this way is merely to see what is there. For the most part, they are anything but avant-garde, but on the other hand, neither are they pure kitsch. The artists had a broader international profile than those of the radical *Gutai-ha*, but their work showed more "serious" artistic intent than the export sculpture and artifacts of the Meiji Period. The prints shy away from political or social commentary, for the most part (although some later works in this exhibition display elements of social critique), taking refuge in landscape, Buddhist architecture and sculpture, folk images, abstractions, and cute animals, but they betray a sincere awareness of and desire for Japanese and non-Japanese subjects and styles, and an almost poignant desire to communicate.[7] In one sense or another – and this can be serious as well as light-hearted – they convey a sense of play, scavenging, reformulating, and creating images in entertaining and provocative ways. In both aesthetic and cultural terms, they exist in a liminal space that, while not all that different from that occupied by much, if not most, art, is also peculiar to and emblematic of its time and place.

[1] Sometimes the smallest details seem replete with possible significance. One notes that all of the signed prints contain signatures written in Roman script, with the name given family name last. Clearly, such a signature seemed to be a necessity for print artists. On the other hand, the orthography for titles is much less consistent. A canny artist such as Saitō meticulously titled his prints in Roman letters. Some artists gave titles in both Japanese and English, while some had titles in Japanese only. It should be mentioned, though, that nearly all of the prints displayed artists' seals – a Japanese signifier of authorship and authenticity – along with the romanized signature.

[2] Helen Merritt, *Modern Japanese Woodblock Prints: The Early Years* (Honolulu: University of Hawaii Press, 1990), pp. 109-124.

[3] Merritt, p.282. Contributors to the set who are also included in this exhibition are Hiratsuka Un'ichi, Maekawa Senpan, Onchi Kōshirō, Azechi Umetarō, Saitō Kiyoshi, Sekino Jun'ichirō, and Yamaguchi Gen.

[4] Oliver Statler, *Modern Japanese Prints: An Art Reborn* (Rutland, Vt. and Tokyo: Charles E. Tuttle, 1956), p.57.

[5] Merritt, p.129

[6] Takashi Murakami, *SUPERFLAT* (Tokyo: Madra Publishing Co., 2000).

[7] This gesture parallels that identified by Christina Klein in *Cold War Orientalism: Asia in the Middlebrow Imagination, 1945-1961* (Berkeley and Los Angeles: University of California Press, 2003). Taking as a point of departure Mary Louise Pratt's formulation of "narratives of anti-conquest," Klein notes that American-produced "middlebrow" texts about Asia were "full of exchanges between Americans and Asians: intellectual exchanges of conversation, economic exchanges of shopping, emotional exchanges of love, physical exchanges of tourism and immigration." (p. 13) The works of the print artists of the same period can be seen as participating in this discourse.

IMAGES AND IMPRESSIONS:

THEMATIC ASPECTS OF MODERN JAPANESE PRINTS FROM THE BERMAN AND CORAZZA COLLECTIONS

FRANK L. CHANCE

The prints of the Berman and Corazza collections present a fascinating cross-section of modern Japanese culture. Though that culture is often characterized as one of homogeneity and tradition, the rich variety of these prints confirms the diversity of view, design, aesthetic, and philosophical approach in the modern Japanese world. From realistic to abstract, woodblock to lithograph, Christian to Buddhist, the variety of these powerful images moves the viewer profoundly.

The majority of the prints in this show are color woodblock prints. The techniques of producing images from blocks of wood were first used in Japan as early as the seventh century, but came to be fully developed in the *ukiyoe* prints of the seventeenth century. By carving an image into a block of wood, most often cherry, then inking the block and pressing paper onto it, professional artisans were able to make hundreds of reproductions of the drawing supplied by an artist. In the eighteenth century, printmaking studios developed methods of aligning the paper on separate blocks to allow the printing of multiple colors. After the middle of the nineteenth century, as Japan moved to modernize, the popularity of woodblock prints decreased, and the techniques almost died out, only to be revived by artists in the twentieth century. In addition to color woodblocks, the exhibition includes monochrome woodblock prints (4), stencil prints (33-35), etchings (52), a screen print (42) and one lithograph (63).

The imagery is as varied as the techniques, including purely abstract designs as well as representations of people, buildings, dogs, cats, and birds, and of course landscapes both real and imaginary. From the naturalistic and highly traditional landscapes of Tokuriki Tomikichirō (12) to the expressively educed forms of Azechi Umetarō (8), the Japanese fascination with the natural world is strongly represented. The human figure is also here, though with less frequency. Among the images of persons, the naturalistic delicacy of Onchi's violinist (2), the sentimental sweetness of Sekino's kimono-clad girl (36), and the folksy directness of Maekawa's flower vendor (1) set a traditionalist tone, yet abstracted forms developed as well, perhaps most extremely in Tajima's *Pierrot and His Son*. (29). Animals and birds appear as well, from Inagaki's cats (10, 11) to Saitō's dachshund (13) to Kimura's singing birds (58).

On another hand, many of the images are more-or-less purely abstract; others use represented forms to envision abstract concepts. Several inculcate music in one way or another. Perhaps the most direct of these is Maruyama Hiroshi's *Round About Midnight No. 7*, a portrait in blue of Miles Davis' trumpet interpreting Thelonious Monk. The songs of forests, birds, and even dogs (48) are invoked as inspirations, while the dancing forms of celebrating figures parade across two etchings (52 and 59). Japanese music is also represented, from the toning of temple bells (61) to puppet theater chants (24) and even the silence of a Buddhist prayer (23).

The abstract notion of spiritual belief is evoked in many images. One artist, Watanabe Sadao, is a deeply committed Christian who derives all his subjects from Old and New Testament stories (33-35). A few prints refer obliquely to Shintō, as for example the *Mountain God, Sea God* (40) by Ushiku Kenji. Many of the printmakers depict Buddhist subjects either directly or indirectly. Both Saitō Kiyoshi (18) and Hiratsuka Un'ichi (4) created images of well-known Buddhist icons, but many more of the prints invoke Buddhist settings – temples and their gardens, buildings, or events. Saitō in

particular uses this technique to inculcate a sense of calm detachment (15, 21, 25, 26). Laying out forms with almost exclusively vertical and horizontal lines in, for example, *Shoji Sanpo-in* (25), establishes stability and quiet in the print; restraining his palette to grays, black, and a gentle brown further lends an atmosphere of meditative silence to the print, while the tiny strip of blue sky pulls the viewer deep into a layered space bounded by gravel, wood, and paper.

Saitō is similarly effective in creating a spiritual atmosphere when evoking Buddhist images directly in two prints. *Mokutō* (23; here translated as *Silent Prayer*) begins with a flattened profile of a fragment of Chinese sculpture, the head of a bodhisattva. By invoking the image of a spiritually awakened being that remains active, he establishes the perfect object for a voiceless entreaty. Surprisingly, the icon faces the right, rather than directly on the viewer; this gives a sense that the image is not in fact the object of the prayer, but a symbolic representation of it. Thus he finesses any question of idol-worship that might linger in the mind of "Mrs. Owen," to whom the print is dedicated.

In his *Buddha Miroku* (18) the reference is even more specific, though the image remains in profile. Despite the title, Saitō was again inspired by images of bodhisattvas, specifically those of seventh century Japan, represented in poses of contemplation. Miroku (Maitreya in Sanskrit) is destined to be the next Buddha who appears in our world at some date in the distant future. He is often represented, therefore, as a bodhisattva, continuing to incarnate from time to time in the quest for completion of his karmic journey, yet untroubled by the events of the world of birth and rebirth. His contemplation of that world is symbolized by his pose, with one leg raised and one hand supporting his chin. In a transitional state between action (symbolized by the lowered leg) and meditation, Miroku waits for his final incarnation and Buddhahood. The quiet natural balance of his mental state is further embodied in the wood grain Saitō used for the background against which the sculptural image is silhouetted.

Chinese Temple Nagasaki (15) takes yet another approach to the building of a quietly profound image. Massing the tiled roofs in a dusky harmony of charcoal grays, Saitō again keeps the palette restrained and dark, with touches of red beams and pillars and patches of white gravel that seem to glisten under an unseen moon. Evoking the exoticism of Nagasaki, at the southeastern extreme of Japan, by naming the print for one of the immigrant temples established there by Chinese refugees in the seventeenth century, Saitō builds an expectation of continental gaudiness, but his print in actuality remains calm with powerful results. Looking down into the compound, we can be transported by imagination into the viewpoint of the visiting Chinese monks, looking with tranquility across their haven of safety from dynastic change.

Tokuriki Tomikichirō's *New Eight Views of Omi* (12) takes an even more traditional approach. Among the artists in this show, Tokuriki is one of the few linked to the *shin hanga* group, artists whose designs were produced by professional artisans who cut, inked, and printed the blocks. Perhaps as a result, he is comfortable with references in this set to print series by Hiroshige and other *ukiyoe* masters, as well as to a thousand years of poetic and painterly history. Beginning in the eleventh century with a series of poems by Song Di on the southern Chinese landscape, the "eight views" were originally defined as follows:

Wild Geese Descending to a Sandbar
Returning Sails off a Distant Coast
Clearing after Rain in a Mountain Market
River and Sky in Evening Snow
The Autumn Moon over Lake Dongting
Night Rain on the Xiao and Xiang Rivers
Evening Bell from a Distant Temple and
Fishing Village in an Evening Glow.

Tokuriki takes these themes, as re-interpreted endlessly in China, Korea, and Japan in the intervening centuries, and produces a "new" set of views. Transposing the scenery around Lake Biwa, in what was Ōmi province until the imposition of the modern prefectures in the 1870's, he brings the ancient poems into harmony with the visitor-friendly modern scenes of the area. The sails now return to *Yabashiri in Early Spring* (12a) and the sunset glows over fishing boats in the *Evening Scene at Hama Otsu* (12b). Snow now blankets Mt. Hira (12d) rather than the river; the moon shines over the Ishiyama temple instead of the lake (12c). The distant temple bell becomes a closer sound at Miidera – booming forth from the famous bell tower at the right side of print 12e. Finally, the whole set was mounted in an album with a cover decorated in the style of an ink painting, even more traditional than the images it contained.

Tokuriki's prints may seem at first less deeply spiritual than, for example, those of Saitō Kiyoshi, yet even in this small set we find many references to Japanese religious tradition. A Shintō shrine and three Buddhist temples are among the eight sites, while the ancient rain-soaked pine tree at Shin-karasaki and the snow-covered peak of Mt. Hira were both sites of focus for religious pilgrims. Ōtsu might have been depicted as a bustling transportation hub, but Tokuriki sets a calm tone in the port, hiding all human figures from view, and letting the sloping pier and floating clouds quiet the scene. He succeeds in establishing these sites as places to see and visit because they are gently beautiful, not because they are loud or boisterously modern.

More abstract subjects were, in general, preferred by the younger artists in the second half of this exhibition. Among them, Maki Haku is perhaps the most prolific; his small prints were exceptionally affordable when they appeared, and continue to be widely available today. His work ranges from abstractions based on ancient calligraphic forms (44, 45, 48) through renditions of natural scenery (46) to depictions of objects with strong cultural overtones (47, 49). The most naturalistic of Maki's images in this exhibition is a richly elegant abstraction from landscape forms, with a crescent moon shining over a tangle of tree branches set against a flat silver sky. In the early *Poems* and *Works* series he used renditions of the Chinese characters imported into Japan in ancient times, sometimes focusing on one simple form (45) to make a bold image. Nearly all his prints are made from carved woodblocks inked with saturated colors; in addition he works with cement and other coatings to produce deep relief textures. Attractive to both Japanese and Western viewers, his images link the ancient past (the characters used on *Poem 69-43* (44), for example, are written in a script that disappeared from general use almost two thousand years ago) with the modern present. The two prints from the *Collection* series (47, 49) are based on the forms of bowls used in the tea ceremony; like the actual bowls, they are profoundly tactile as well as visually appealing. By keeping the colors simple and strong, he creates a sense of spiritual ease, a kind of meditative quiet that calms the viewer even as the rough surface textures capture our eyes. We are led, in the end, to contemplate the depths of history, calmed by the strength of the simple forms as powerful contrasts that Maki presents as finished products.

Throughout these prints, whether or not they depict traditionally spiritual subjects, the printmakers walk a fine line between the modern international world and their national pasts. By choosing a medium with a venerated history, they invite themselves to loiter in the world of the past, yet all of them bring profoundly modern sensibilities to play in their work. Even the most conservative of the printmakers (Tokuriki, for example, and perhaps Hiratsuka) bring bold touches of innovation to their presentations. The young abstractionists, by contrast, maintain a level of professional technical skill allowing them a full range of expression without restraint. The representational prints give us figures and scenes to consider, while the abstracts provide mysteries to contemplate without the clarity of definitive answers. Our eyes are delighted by the colors and forms, while our minds are simultaneously calmed and intrigued by their spiritual depth.

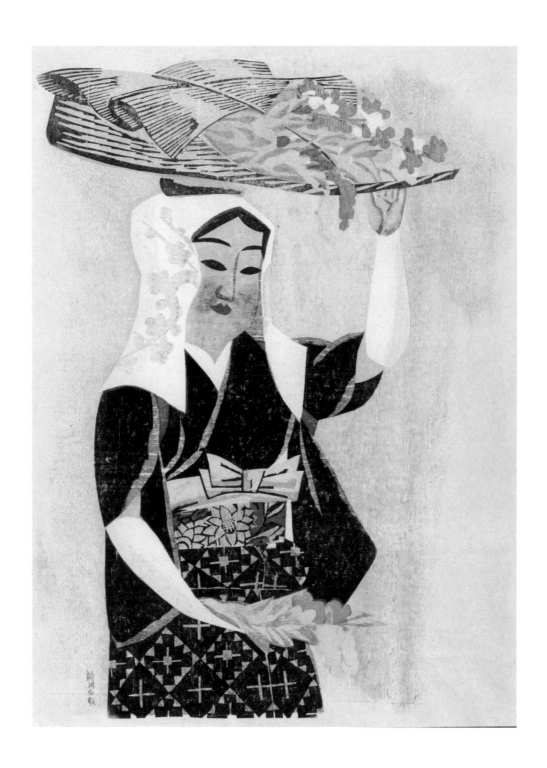

1 Maekawa Senpan *Flower Vendor*

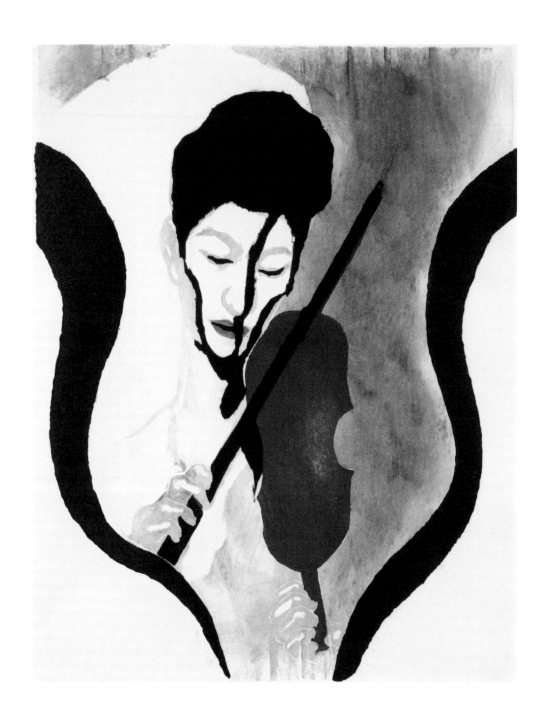

2 Onchi Kōshirō *Violinist*

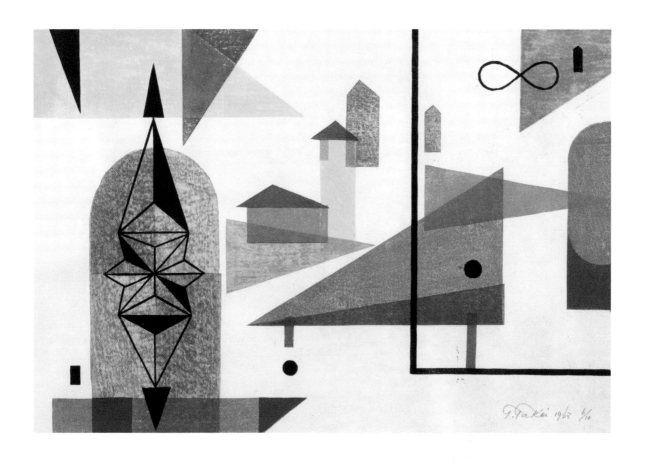

3 Takei Takeo *Untitled*

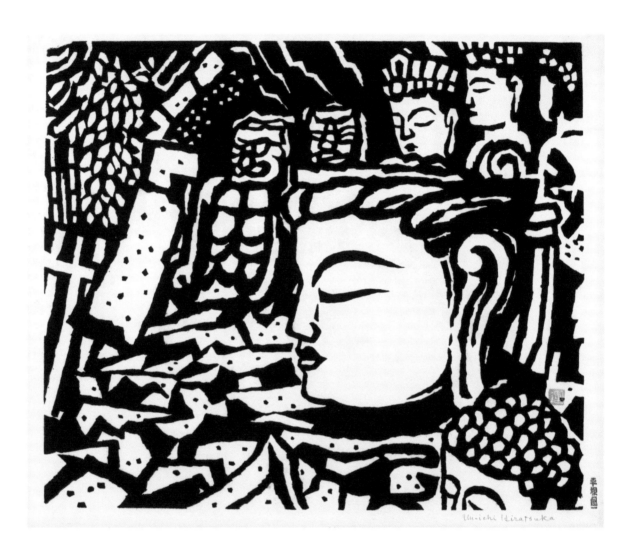

4 Hiratsuka Un'ichi *Usuki Buddha*

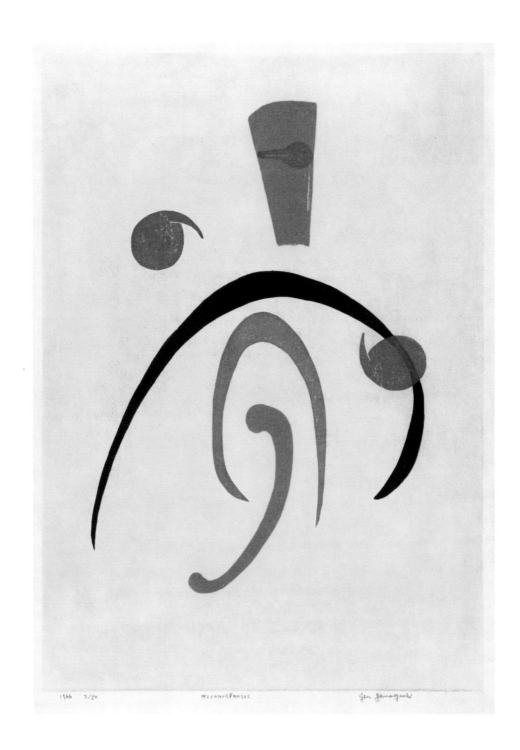

5 Yamaguchi Gen *Metamorphosis*

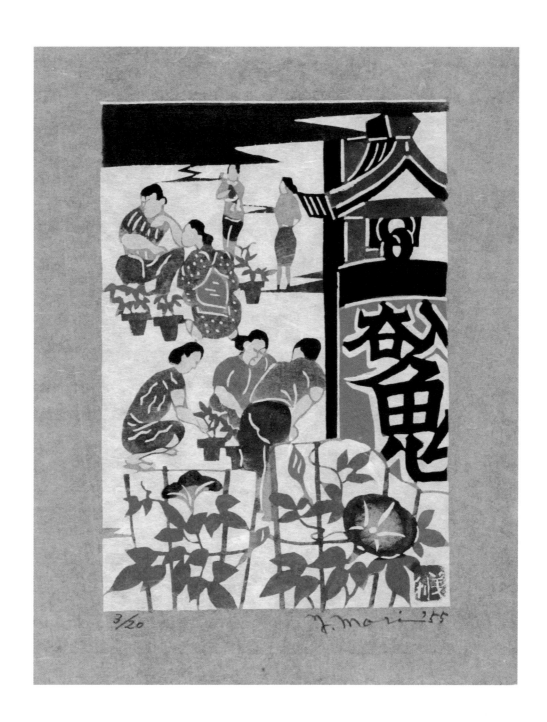

3/20

6 Mori Yoshitoshi *Morning Glory Market at Kishimojin Temple*

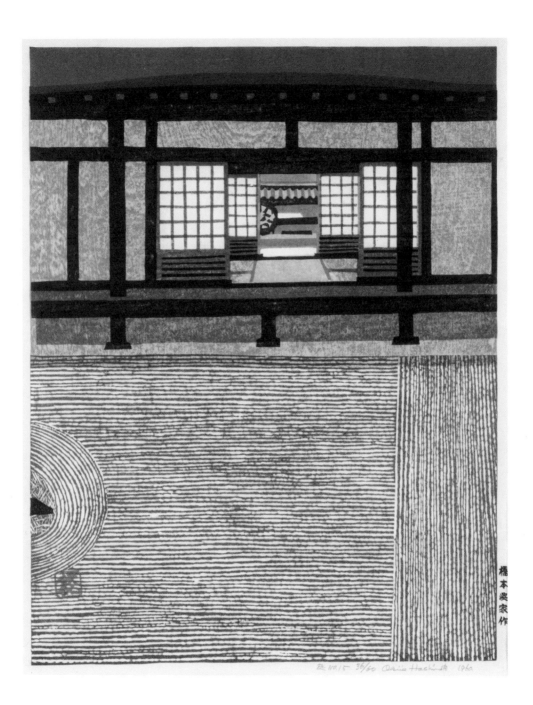

7 Hashimoto Okiie *Garden No. 15*

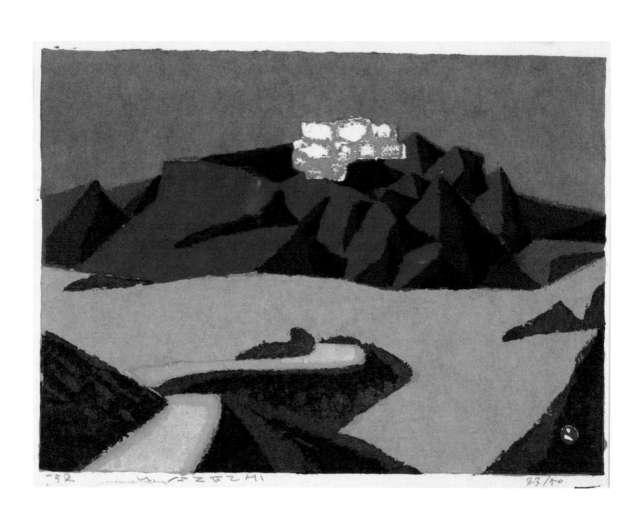

8 Azechi Umetarō *Landscape – Mountaineer Series*

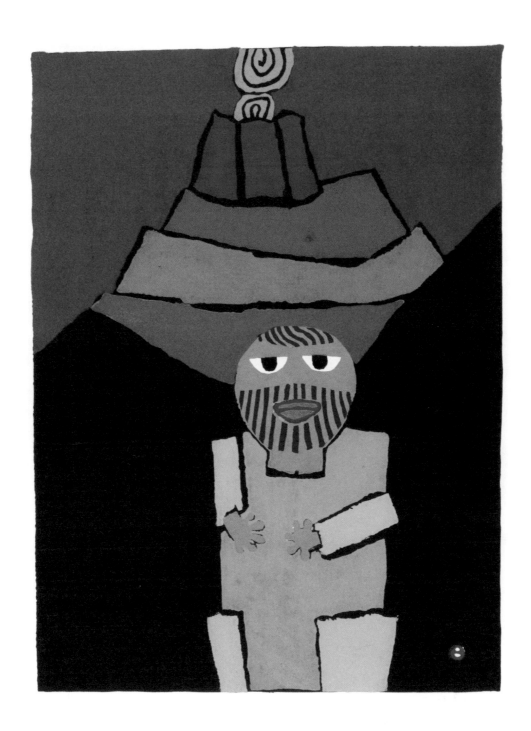

9 Azechi Umetarō *Awe of the Mountain*

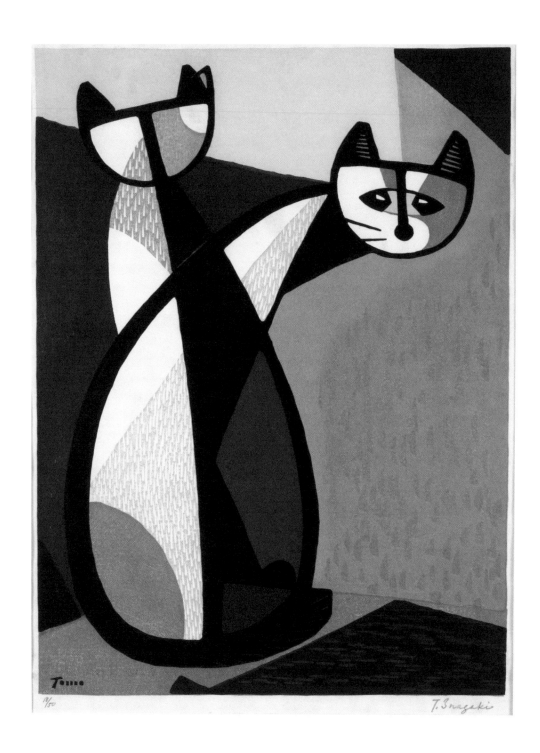

10 Inagaki Tomoo *Cat Looking Backwards*

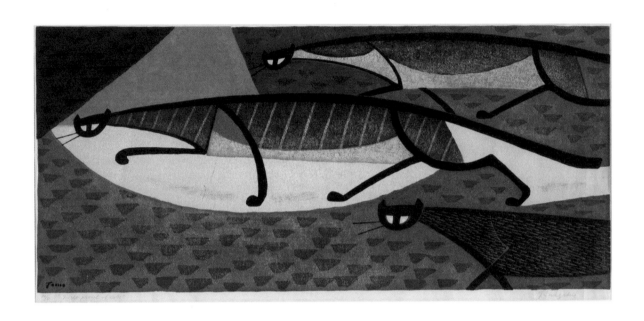

11 Inagaki Tomoo *Night Prowl of Cats*

12 Tokuriki Tomikichirō *New Eight Views of Omi (album cover)*

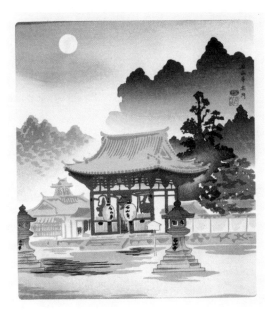

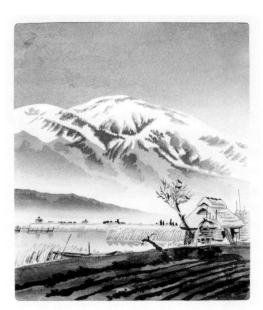

Tokuriki Tomikichirō

12a *Yabashiri in Early Spring*

12b *Evening Scene of Hama-Otsu*

12c *The Full Moon of Ishiyama Temple*

12d *Mt. Hira Covered with Evening Snow*

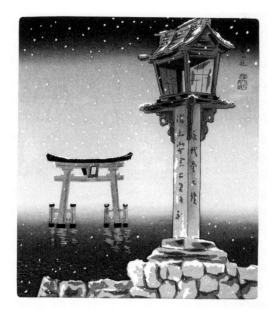

Tokuriki Tomikichirō

12e *Lake Biwa Viewed at Miidera Temple*

12g *Katata Ukimido Temple*

12f *The Pine-Trees of Shinkarasaki*

12h *Shirahige Shrine*

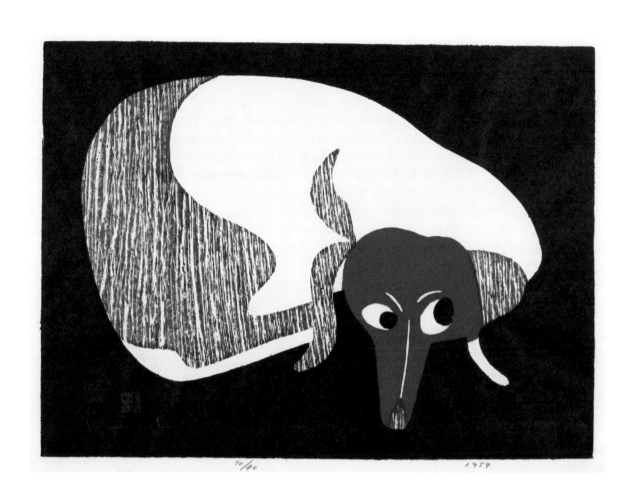

13 Saitō Kiyoshi *Sleeping Dachshund*

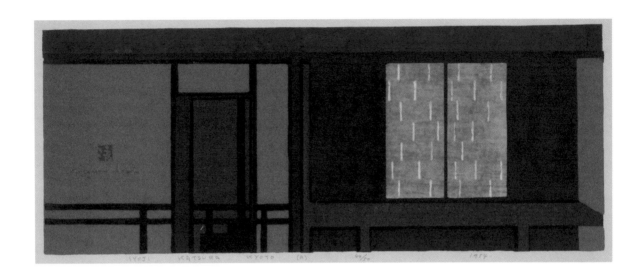

14 Saitō Kiyoshi *Syoji Katsura Kyoto (A)*

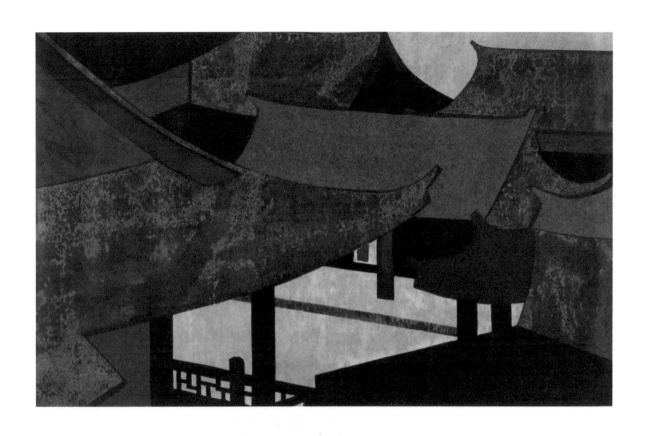

15 Saitō Kiyoshi *Chinese Temple Nagasaki*

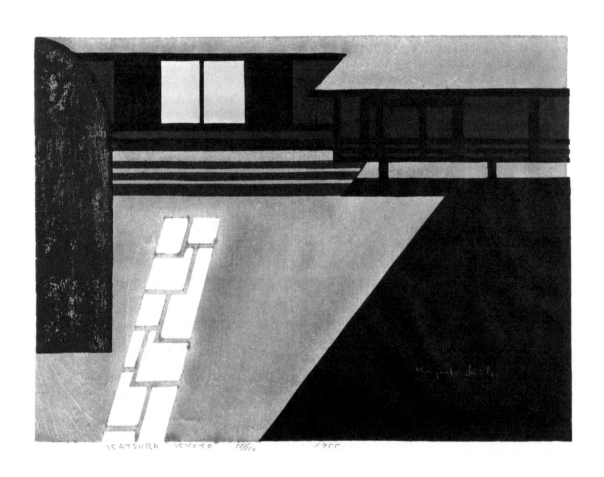

16 Saitō Kiyoshi *Katsura Kyoto*

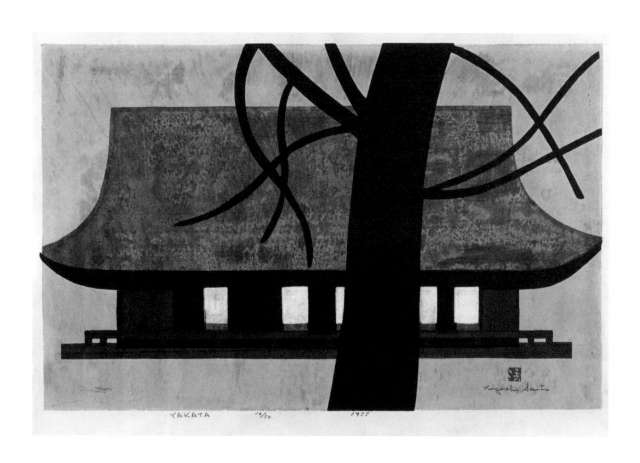

YAKATA 16/50 1955

17 Saitō Kiyoshi *Mansion*

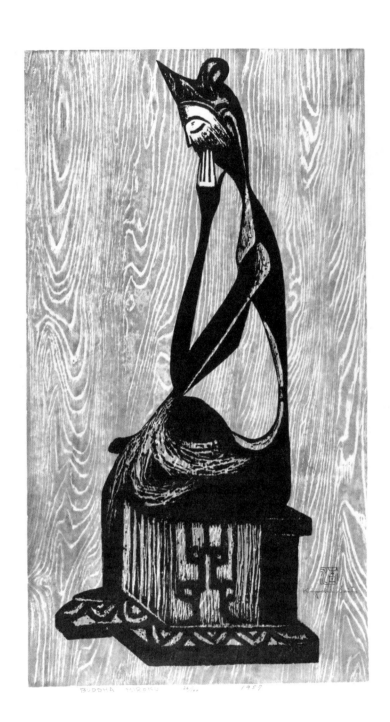

18 Saitō Kiyoshi *Buddha Miroku*

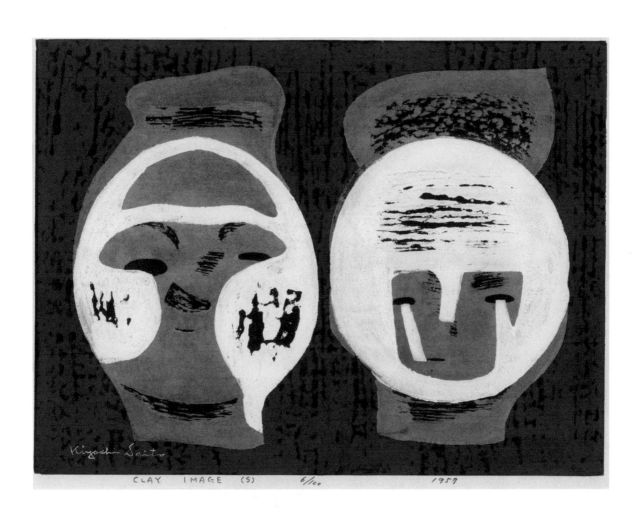

19 Saitō Kiyoshi *Clay Image (S)*

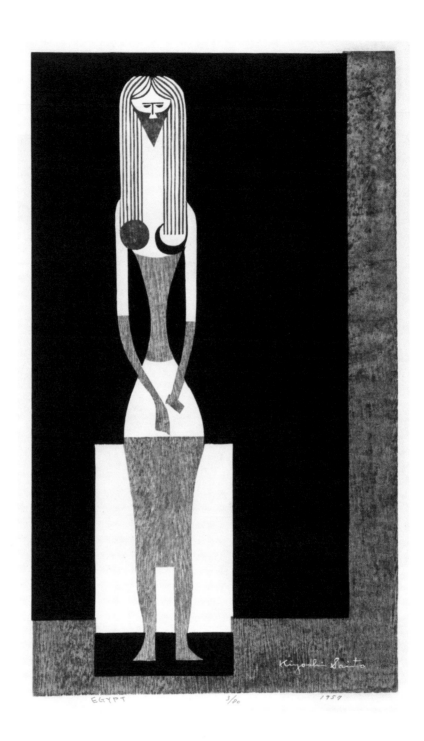

EGYPT 3/00 1959

20 Saitō Kiyoshi *Egypt*

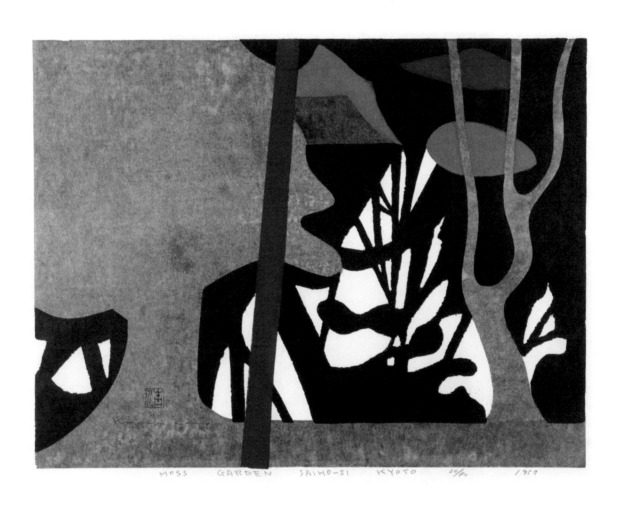

MOSS GARDEN SAIHO-JI KYOTO 20/P₀ 1957

21 Saitō Kiyoshi *Moss Garden Saiho-ji Kyoto*

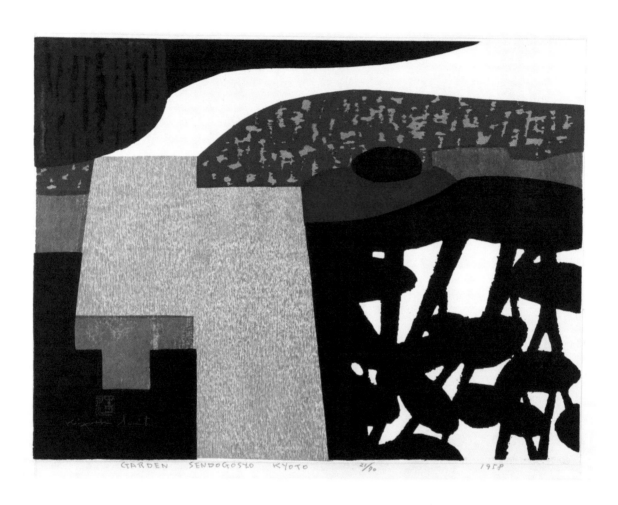

GARDEN SENDOGOSYO KYOTO 21/90 1958

22 Saitō Kiyoshi *Garden Sendogosyo Kyoto*

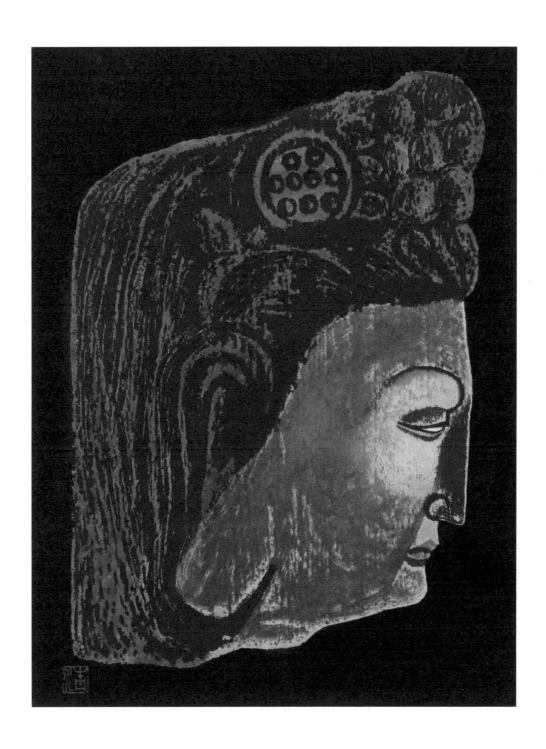

23 Saitō Kiyoshi *Silent Prayer*

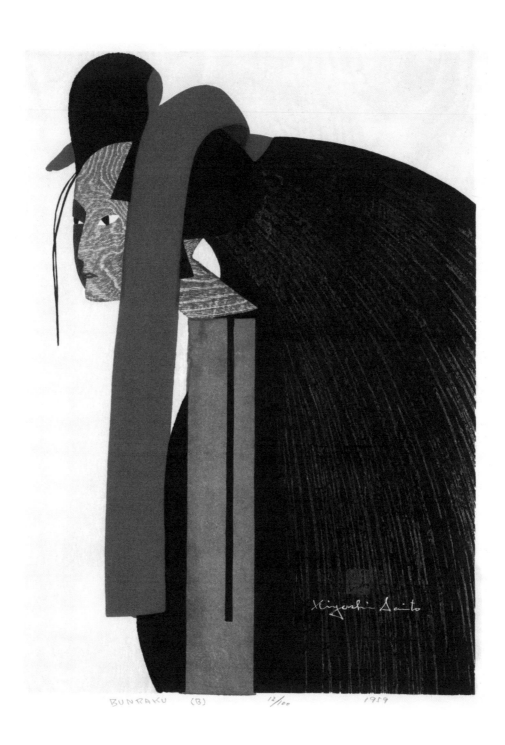

BUNRAKU (B) 12/100 1959

Kiyoshi Saito

24 Saitō Kiyoshi *Bunraku (B)*

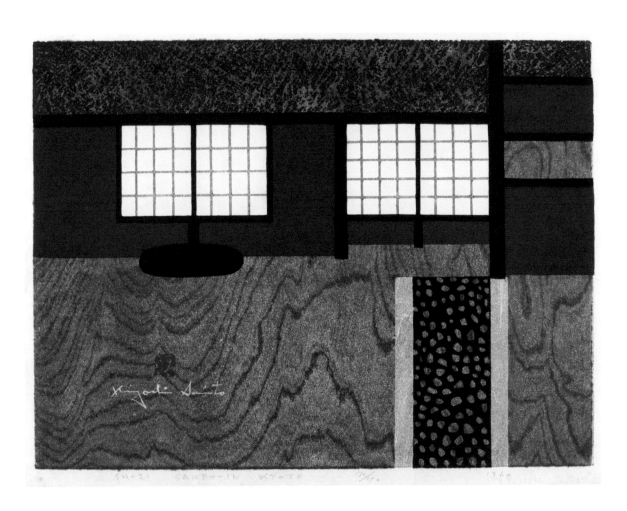

25 Saitō Kiyoshi *Shoji Sanpo-in Kyoto*

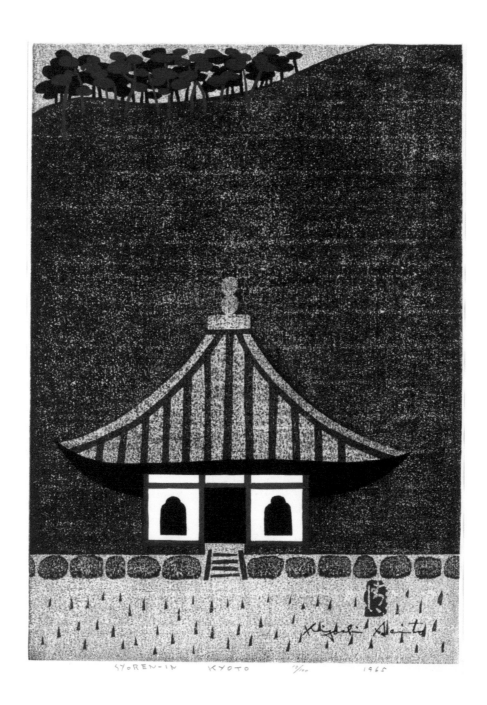

26 Saitō Kiyoshi *Syoren-in Kyoto*

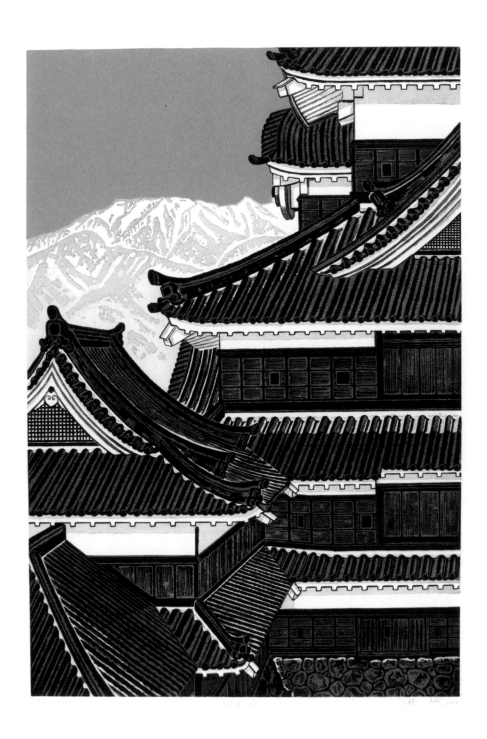

27 Ueno Makoto *Matsumoto Castle*

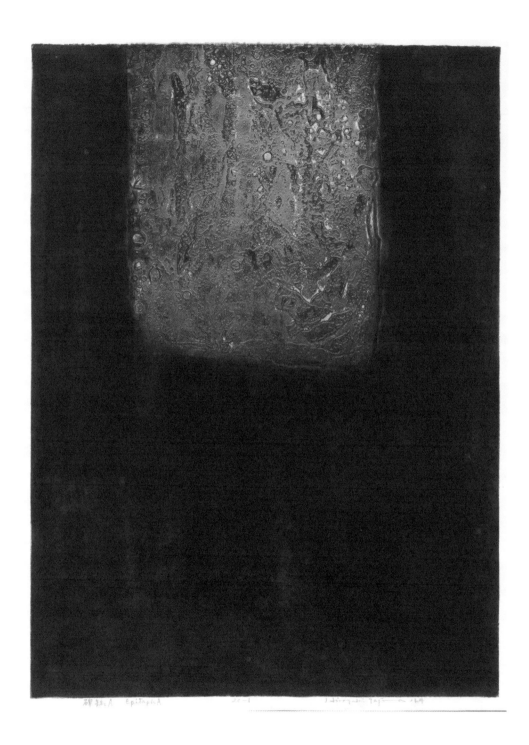

28 Tajima Hiroyuki *Epitaph A*

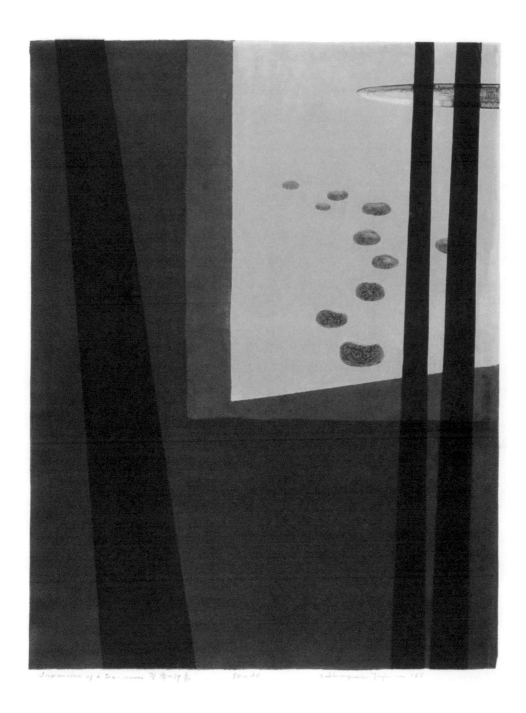

29 Tajima Hiroyuki *Impression of a Tea-room*

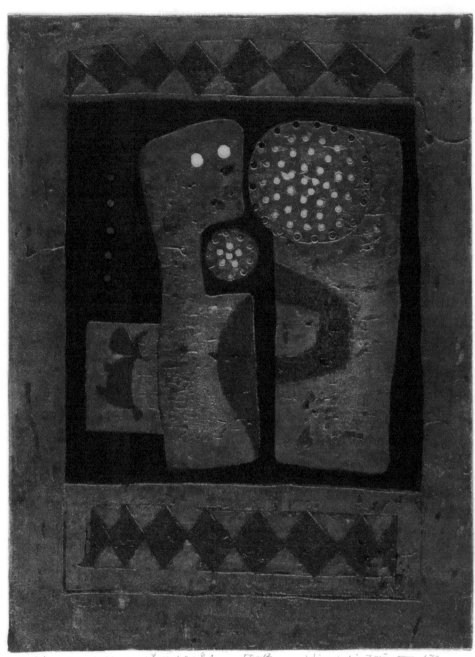

30 Tajima Hiroyuki *Pierrot and His Son*

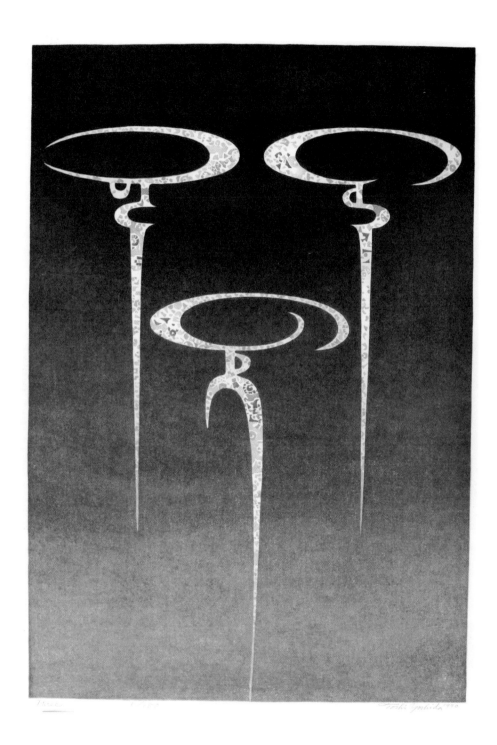

31 Yoshida Tōshi *Three*

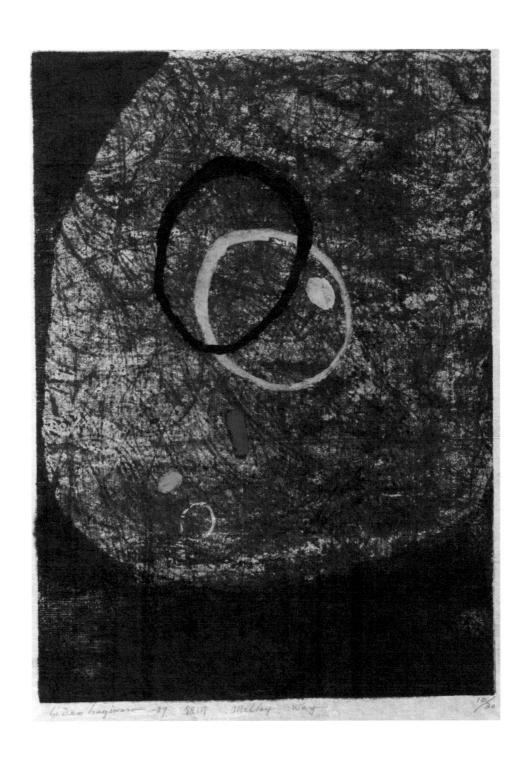

32 Hagiwara Hideo *Milky Way*

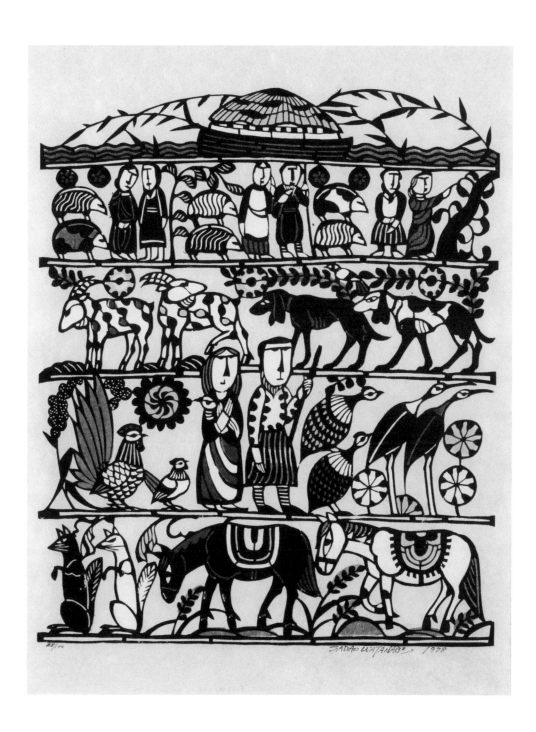

33 Watanabe Sadao *Noah's Ark*

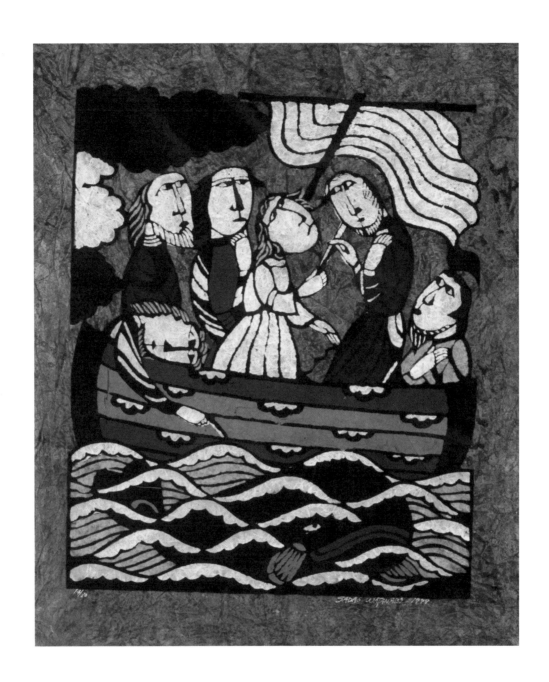

34 Watanabe Sadao *Jonah and the Whale*

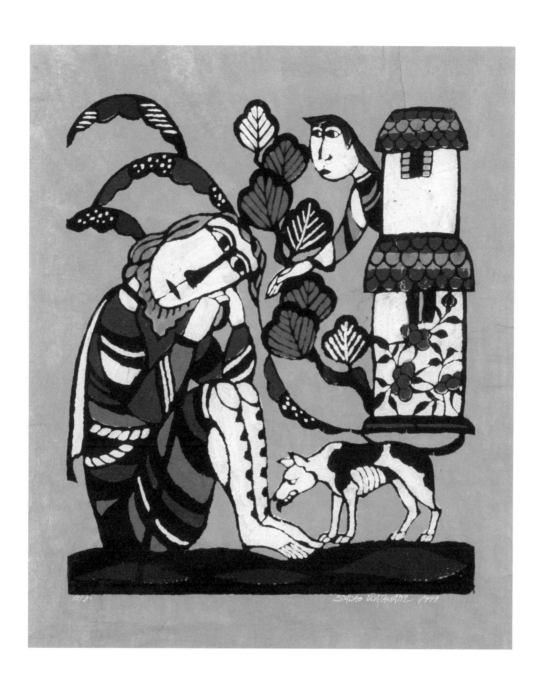

35 Watanabe Sadao *Lazarus the Beggar*

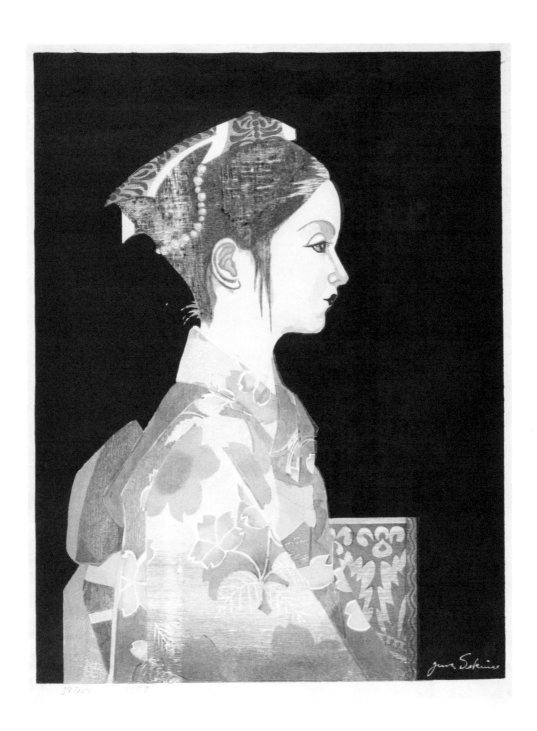

36 Sekino Jun'ichirō *Girl in Kimono*

37 Kitaoka Fumio *Snow Scene*

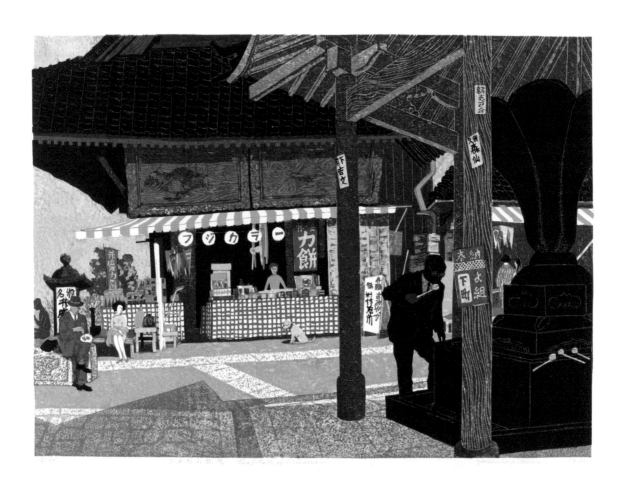

38 Kitaoka Fumio *Tea Stall at Miidera*

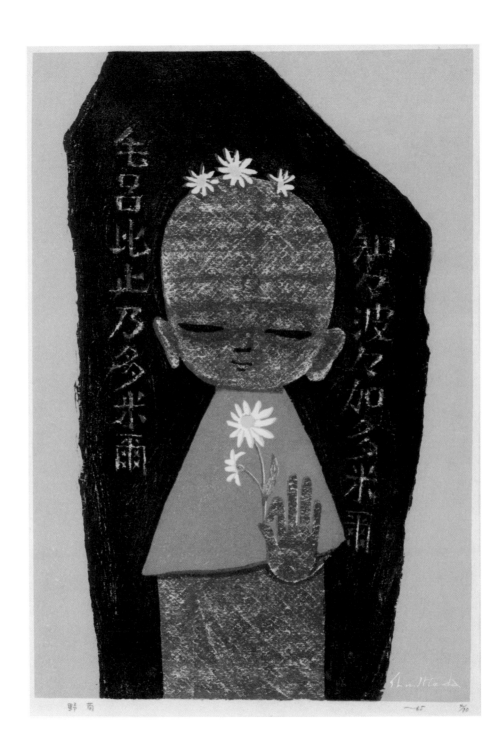

39 Ikeda Shūzō *Wild Chrysanthemums*

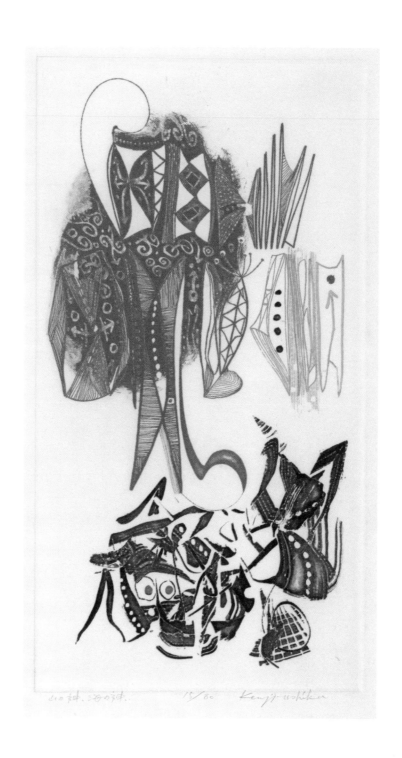

40 Ushiku Kenji *Mountain God, Sea God*

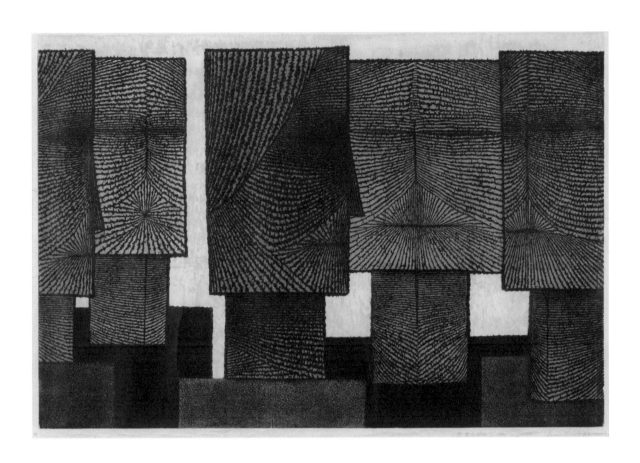

41 Kinoshita Tomio *Masks (I)*

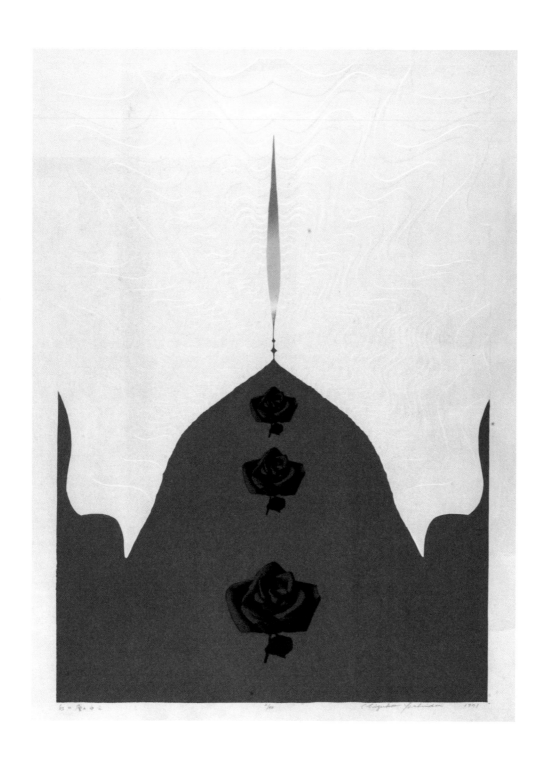

42 Yoshida Chizuko *Into the White Strata*

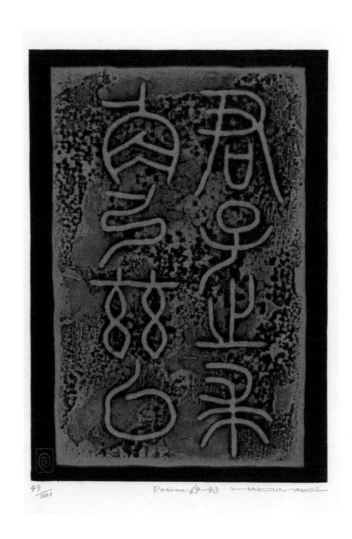

43 Maki Haku *Poem 68-16* 44 Maki Haku *Poem 69-43*

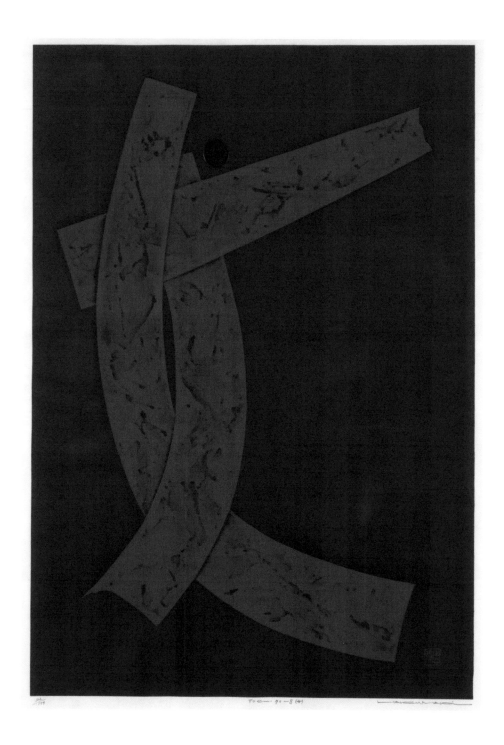

45 Maki Haku *Poem 70-8 (Woman)*

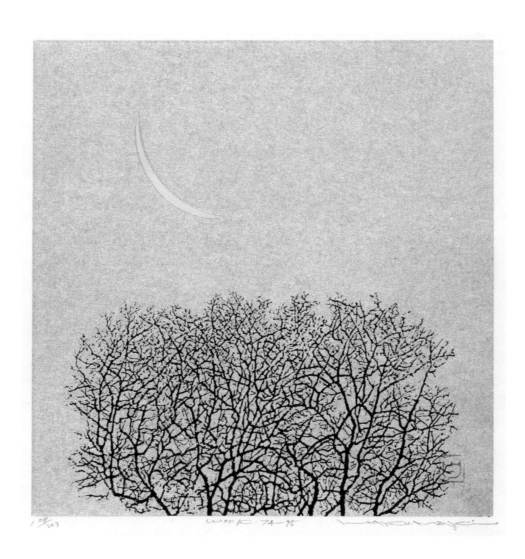

46 Maki Haku *Work 74-95*

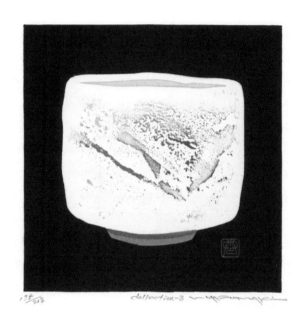

47 Maki Haku *Collection 35* 49 Maki Haku *Collection 3*

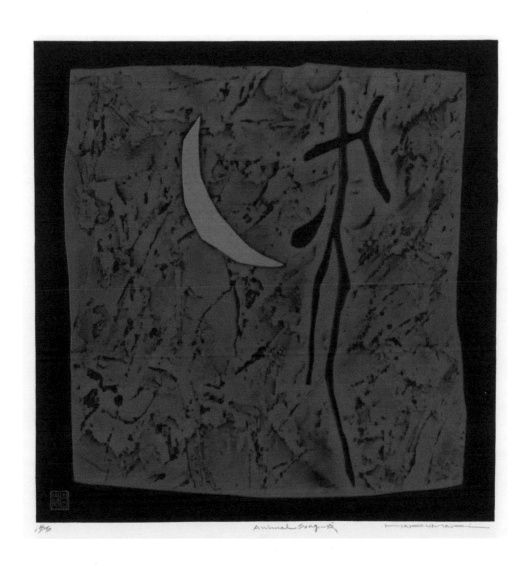

48 Maki Haku *Animal Song – Dog*

50 Iwami Reika *Sea, Evening Calm*

51 Yoshida Hodaka *Enclosure <Village>*

52 Shibuya Eiichi *Carnival*

53 Amano Kunihiro *Morning Moon (J)*

54 Amano Kunihiro *Castle Gate II*

10/50 われらの時代 G.Kumagai

55 Kumagai Gorō *Our Generation*

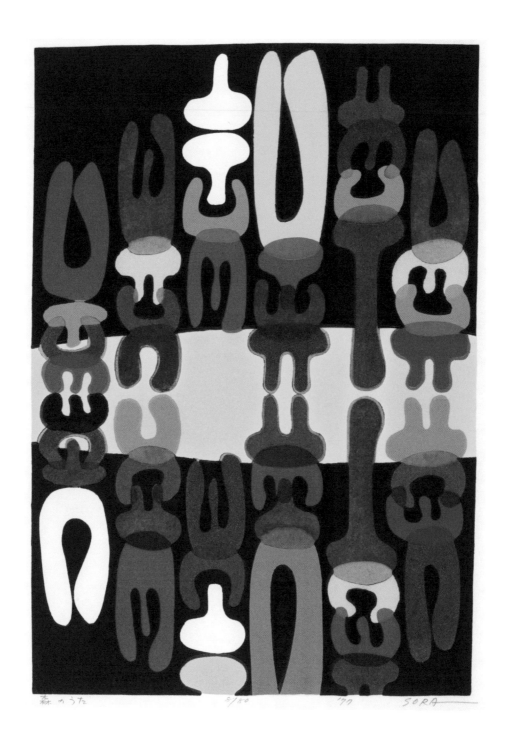

森のうた 5/80 '77 SORA

56 Sora Mitsuaki *Song of the Forest*

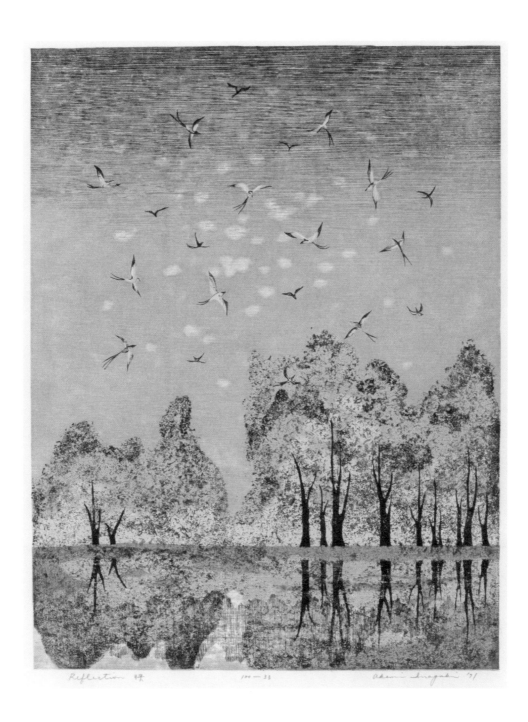

Reflection 57 100 — 33 akemi inagaki '91

57 Inagaki Akemi *Reflection*

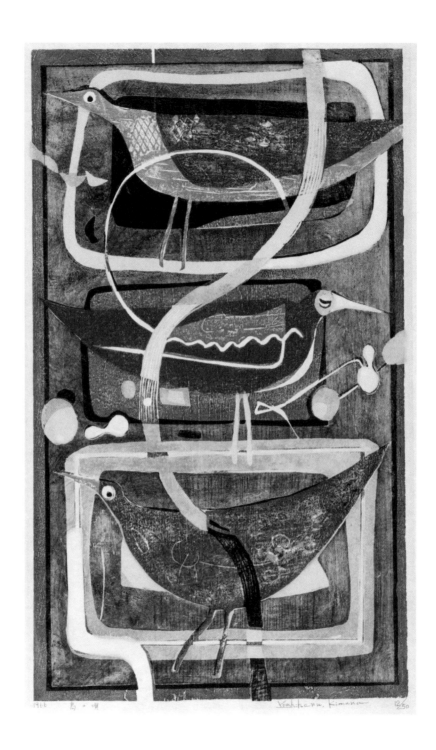

58 Kimura Yoshiharu *Song of Birds*

59 Katayama Mika *Red Parade*

1991 4/30 Work 71-14 KEN KUSAKA

60 Kusaka Kenji *Work 71-14*

61 Shima Tamami *Bell Tower*

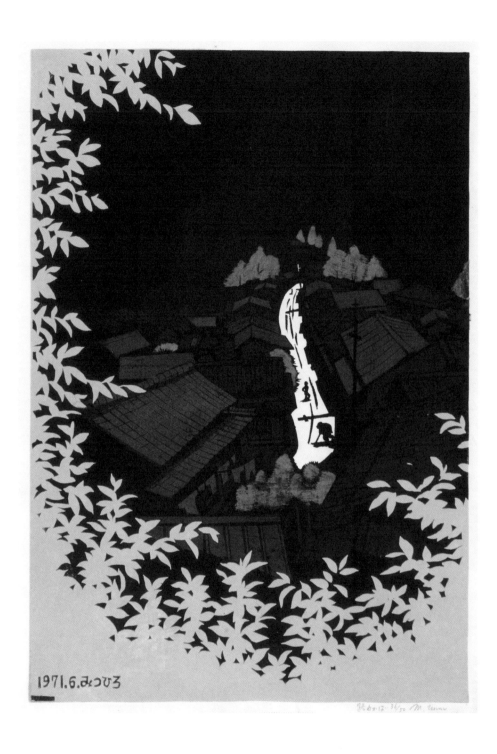

62 Unno Mitsuhiro *New Leaves on the Wayside*

63 Takabe Taeko *At Play in the Depths of the Sea*

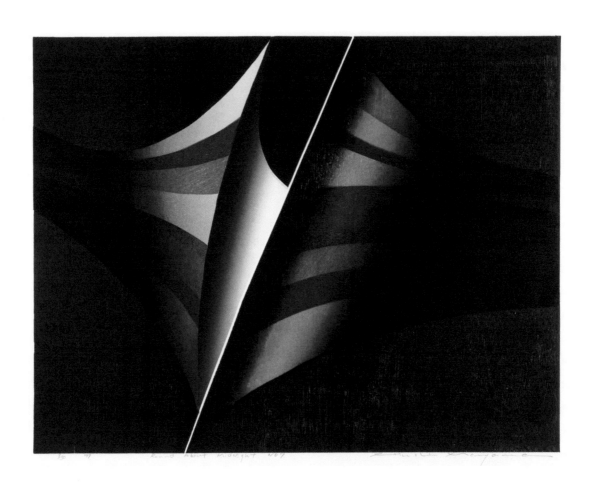

64 Maruyama Hiroshi *Round About Midnight No. 7*

WORKS IN THE EXHIBITION

Artists are listed in order of birth.

Japanese names appear with family name followed by given name. In some quotations, the names are given in the reverse order.

Artist signatures are written in the bottom margin in pencil using Roman letters. Titles are written in English in pencil in the bottom margin. Exceptions are noted.

Dimensions: height precedes width.

The main source for the biographies is Merritt and Yamada. This and other references can be found following the checklist in the list of works consulted.

Given the importance of artists' associations in the Japanese art world, membership is noted for some of the more historically significant ones, including Nihon Sōsaku Hanga Kyōkai (Japan Creative Print Association, founded in 1918), Nihon Hanga Kyōkai (Japan Print Association, founded in 1931, and into which the Nihon Sōsaku Hanga Kyōkai was absorbed), and Joryū Hanga Kyōkai (Women's Print Association, founded in 1956).

Nihon Hanga Kyōkai continues to be active, with 187 members and 181 associate members as of 2003. It hosts an annual exhibition of prints, at which it awards several prizes, including ones named after Azechi Umetarō and Yamaguchi Gen.

Affiliation with one general art organization, Kokugakai (National Picture Association), is also noted. Kokugakai is one of the very few major art associations that has recognized prints as a legitimate form of fine art. Its annual exhibition has included prints since 1928. The Japanese-style painters left the organization in that same year, and the Kokugakai has focused on Western-style painting and prints ever since.

MAEKAWA Senpan　前川千帆
1888-1960

Born in Kyoto as Ishida Shigezaburō. Studied at art school under the painter Asai Chū, and worked as a cartoonist. Became active as a woodblock printmaker ca. 1919 and was a founding member of Nihon Hanga Kyōkai. Many of his prints depict the lives of ordinary people, often with a tone of sentiment and nostalgia.

1 *Flower Vendor*
Woodblock print, undated
15 1/4 x 11 1/4" (image)
Gift of Dr. Leo and Mary Corazza
Provenance: The Red Lantern Shop, Kyoto

A similar print reproduced in Statler (plate 22) is dated 1951.

Stamped in red 前川千帆 recto. Untitled recto. In pencil verso, "Flower Vendor."

The representation of the woman in this print is typical of depictions of *Ohara-me*, or "maiden of Ohara," a village located north of Kyoto which is famous for its rustically beautiful flower-vendors. The style is evocative of folk art, particularly that associated with the *mingei* movement.

ONCHI Kōshirō　恩地孝四郎
1891-1955

Born in Tokyo. Father was a tutor of imperial princes. Studied painting and sculpture at Tokyo School of Fine Arts. Was involved in the publication of several magazines of art and literature. Involved in Nihon Sōsaku Hanga Kyōkai and Nihon Hanga Kyōkai. Exhibited with Kokugakai. Was a leading figure in the postwar Japanese print world and a mentor to many artists. Although he never visited Europe, he was highly influenced by such artists as Wassily Kandinsky, and his prints tended to be abstractions. In spite of this, two of his most famous prints are portraits: one of the poet Hagiwara Sakutarō (see 48), and the other of a violinist (2).

2 *Violinist*
Woodblock print, undated
16 1/8 x 12 7/8" (image)
Gift of Philip and Muriel Berman
UC1989.2.032
Provenance: R. Snyder Collection, New York (March 1968)

Reproduced in:
Kindai Nihon hanga taikei, v.2, plate 23, as "Violin."
Kuwayama, p.22 (cat. no. 4), as "Impression of a Violinist" (trial impression with different coloring from final version).
Statler, frontispiece, as "Impression of a Violinist."

This unsigned, undated and untitled print is identified in several sources as *Impression of a Violinist*. *Kindai Nihon hanga taikei* dates it at 1946, and Kuwayama and Statler date it at 1947. Statler notes that Onchi made only 13 prints, and that after Onchi's death, another printer made "an indefinite number as a memorial edition." (185) It is likely that this print is from that edition.

According to Statler, "Onchi made this print after hearing a concert by Nejiro Suwa…He also wrote a companion poem, dated October 29, 1947, which has been translated as follows:

Impression of a Violinist

The bow rises strongly into the air,
The artificial lights turned on this violinist's slender body,
How yellow they seem! –
On her pale face, on the white silk,
This body passed through a Europe torn with war,
And stands now on the stage of an occupied country.
Ah, the sounds of rubbing strings keep
gnawing at one's heart,
How sad a thing art is!
My heart turns yellow,
My tears turn yellow too." (185-186)

The mournful quality of the poem is matched by the nearly monochrome print, with the masklike face marked with expanses of black and facing downward, and the violin pointing down. This movement is counterbalanced, however, by the "V" shape opening towards the top. The print may capture the complex and ambivalent emotions of the early postwar period. Kuwayama notes the influence of Edvard Munch. (22)

TAKEI Takeo 武井武雄
1894-1983

Native of Okayama in Nagano Prefecture. Was most famous as an illustrator of children's books, but his style ranged from representational to abstract. Early influences included Cezanne, van Gogh and Gauguin. "When my prints were shown in America, some critics cited the influence of Miro, but the fact was that I had never seen a Miro. I've seen some of his work now, but I feel much more akin to [Paul] Klee." (Statler, 96)

3 Untitled
Woodblock print, 1963
Numbered 6/10
12 3/8 x 18 1/4" (image)
Gift of Dr. Leo and Mary Corazza
Provenance: The Red Lantern Shop, Kyoto

Signed "T. Takei."

Also known as "Factory Making Dream." The image is a blend of abstraction and representation, in a style that is playful and childlike in a way reminiscent of Klee.

HIRATSUKA Un'ichi 平塚運一
1895-1997

Born in Matsue, Shimane Prefecture. As a young man he moved to Tokyo, where he studied woodblock carving. A leader of the *sōsaku hanga* movement and a teacher of many printmakers. Member of Nihon Sōsaku Hanga Kyōkai and a founding member of Nihon Hanga Kyōkai. Served as head of print section of Kokugakai from its inception in 1931. Most renowned for black-and-white prints of landscapes and Buddhist themes. Hiratsuka borrowed from Western woodcarving technique, but was particularly influenced by Heian period Buddhist prints and paintings, as well as the brush paintings of Taiga, Buson and Sesshū. He has said, "I have always tried for power and strength in my pictures. I have done some Japanese-style brush painting, but I always come back to prints because I feel that they are stronger. I'm convinced that, had advanced block printing existed in Sesshū's day, he would have deserted brush painting." (Statler 38) Moved to Washington, D.C. in 1962, where he made prints depicting such landmarks as the Capitol.

4 *Usuki Buddha*
Woodblock print, undated (1941?)
15 x 17 7/8" (image)
Gift of Philip and Muriel Berman
UC1989.6.004
Provenance: R. Snyder Collection, New York (March 1968)

Reproduced in *Hiratsuka: Modern Master* on p.69 (cat. no. 38), as "Fragments of Buddhist Sculpture at the Usuki Site, Ōita," dated 1941. The title written on the print itself is "Stone Buddhas at Usuki."

Untitled recto. "Usuki Buddha" in pencil verso.
Signed "Un-ichi Hiratsuka" and stamped in red 平塚運一.
Seal on print.

A depiction of stone sculptures of Buddha found in Usuki, located on the island of Kyushu. The site, a national historical monument, contains 59 stone Buddhas carved into a mountainside. The sculptures are estimated to date from the 12th-14th centuries.

Most of Hiratsuka's prints are in black and white, which he called "the most beautiful of the colors." (Statler 27)

YAMAGUCHI Gen 山口源
1896-1976

Born in Shizuoka Prefecture, but grew up in Tokyo. Studied with Onchi Kōshirō, whose abstract style was a major influence. A Christian and an anti-militarist, Yamaguchi encountered personal difficulties during the 1930's. Member of Nihon Hanga Kyōkai. Exhibited with Kokugakai.

5 *Metamorphosis*
Woodblock print, 1966
Numbered 3/50
23 3/4 x 16 7/8" (image)
Gift of Dr. Leo and Mary Corazza

Signed "Gen Yamaguchi."

The organic interlocking forms are reminiscent of works by Yamaguchi's teacher Onchi, and also can be linked to the abstract expressionism of such Western artists as Wassily Kandinsky, Paul Klee, Alexander Calder, and Jackson Pollock.

MORI Yoshitoshi　森義利
1898-1992

Born in Tokyo. Studied fabric dyeing and Japanese-style painting, and became influenced by the *mingei* (folk art) movement during the war. Made mostly stencil prints, showing influence from Serizawa Keisuke, but also made some woodcuts. Member Nihon Hanga Kyōkai and Kokugakai. According to Merritt and Yamada, his "subjects are often workers at traditional tasks, festivals, exotic imagery of Buddhism, or folk art. Style is bold in *mingei* taste." (95)

6 *Morning Glory Market at Kishimojin Temple*
Stencil print, 1955
Numbered 3/20
12 3/4 x 10 7/8" (image)
Gift of Dr. Leo and Mary Corazza
Provenance: The Red Lantern Shop, Kyoto (1975)

Reproduced in *Kindai Nihon hanga taikei*, v.2, plate 307.

Untitled. Seal on image. Signed "Y. Mori."
Also known as "Market of Morning Glories."

Every year, for three days starting July 6th, a market of morning glories 朝顔市 (*asagao ichi*) takes place at the Kishimojin Temple in the Iriya section of Tokyo. The immensely popular fair has been held for some 300 years; as such, it represents a connection to a simpler age.

The three-part composition is simple yet striking. At the bottom, we see a closeup of morning glories. The top sections situate the flowers, with people at the market on the left, and a red lantern printed with "Iriya" at the top and the "*ki*" of Kishimojin below. The three different spaces coexist harmoniously on the same flat plane. The character for "*ki*" means "demon," and might by itself be ominous, but Kishimojin, once a demonic mother who killed other people's children to feed her own, was shown the light by the Buddha and took a vow to protect all children and also help mothers with childbirth.

HASHIMOTO Okiie　橋本興家
1899-1993

Born in Tottori Prefecture. Studied at Tokyo School of Fine Arts. After studying with Hiratsuka Un'ichi, became a member of his circle of artists. Member of Nihon Hanga Kyōkai and Kokugakai. Was an art teacher and administrator, but retired early to devote himself to making art. Merritt and Yamada note that he is "especially known for large, strong, colorful prints of gardens and ruined castles." (30)

7 *Garden No. 15*
Woodblock print, 1960
Numbered 36/60
21 1/4 x 16 3/4" (image)
Gift of Philip and Muriel Berman
UC1989.4.023

Provenance: R. Snyder Collection, New York (March 1968)

Signed "Okiie Hashimoto." Seal on image. Name stamped in *kanji* in right margin.

Title given in both English and Japanese (庭 No. 15). It is interesting to compare this print with several similar ones by Saitō. Both artists are attracted to the geometrical simplicity of traditional Japanese architecture, but Hashimoto seems more concerned with creating a three-dimensional representation (note the use of vanishing point perspective), while Saitō emphasizes the abstract quality of the forms themselves, in a manner that is more two-dimensional.

AZECHI Umetarō　畦値梅太郎
1902-1999

Born in Uwajima, in Ehime Prefecture, on the island of Shikoku. Largely self-taught, he began to make prints while working in a government printing office. Obtained support for his art from Hiratsuka, Onchi and Maekawa. Member of Nihon Sōsaku Hanga Kyōkai, Nihon Hanga Kyōkai, and Kokugakai, and contributed illustrations to many magazines. Exhibited internationally. His most noted motif, developed after the war, incorporates his memories of home in depictions of mountain landscapes and mountain folk portrayed in a naïve style reminiscent of folk art, with large spaces of flat, saturated color that seem almost abstract. A champion of rural culture, he wrote numerous essays about mountains.

8 *Landscape - Mountaineer Series*
Woodblock print, 1952
Numbered 23/50
11 1/2 x 16-1/8" (image)
Gift of Philip and Muriel Berman
UC1989.1.071
Provenance: R. Snyder Collection, New York (March 1968)

Untitled recto. Signed "U. Azechi." Seal on print.

This landscape from Azechi's Mountaineer Series is more sophisticated graphically than the following work, and in this sense, less representative of his most mature style. There is shading and modeling in the image, making it more representational and less abstract. Nevertheless, the image evokes a sense of awe, strengthened by the volcano's inaccessibility and its isolation from civilization, represented by the abrupt breaking off of the road that approaches it.

9 *Awe of the Mountain*
Woodblock print, 1967
Numbered 30/50
20 x 14 7/8" (image)
Gift of Dr. Leo and Mary Corazza

Reproduced in Petit, v.1, b/w plate no. 21, as "Fear of the Mountain (A)."

Signed "U. Azechi." Seal on print.

The print has no English title inscribed on it. The Japanese title, 山のおそれ (*yama no osore*) is translated here as "Awe of the Mountain." The Japanese is vague enough that it could be either the man or the mountain that is feeling a

sense of awe. Although "*osore*" is usually translated as "fear," it can be thought that Azechi's prints contain overtones of traditional mountain worship, in which nature, which is regarded by people with veneration, is also considered to possess spirit, even sentience itself. The image of the volcano in eruption indicates that the mountain is indeed alive.

This print is noteworthy for its avoidance of typical "Orientalist" imagery, its flavor of folk (almost primitive) style presented with a contemporary sensibility, its extreme flatness without any attempt at modeling, and its presentation of a figurative image in a technique that is almost abstract. At once childlike and sophisticated, this image is representative of much that is most striking about *sōsaku hanga*.

INAGAKI Tomoo　稲垣知雄
1902-1980

Born in Tokyo. Studied with Onchi Kōshirō and Hiratsuka Un'ichi. Exhibited with Nihon Sōsaku Hanga Kyōkai. Member Nihon Hanga Kyōkai and Kokugakai. Most noted for his "highly stylized prints of cats," (Merritt 41) including his own pets. (Statler 165)

10 *Cat Looking Backwards*
Woodblock print, undated
Numbered 18/50
16 x 21" (image)
Gift of Philip and Muriel Berman
UC1989.4.027
Provenance: R. Snyder Collection, New York (March 1968)

Untitled recto. Signed "T. Inagaki."

The back view of a curious, yet detached feline, incorporates the Futurist element of multiplying body forms, much like the legs of the dachshund in Giacomo Balla's *Dynamism of a Dog on a Leash*. The effect here, however, is not the creation of a radical modern vision but a sentimental, cute evocation of an eternally curious creature.

11 *Night Prowl of Cats*
Woodblock print, undated
Numbered 20/50
35-1/4 x 15-1/2" (image)
Gift of Philip and Muriel Berman
UC1989.4.026

Signed "T. Inagaki."

Inagaki adopts the streamlined forms of art deco to create a vivacious tongue-in-cheek vision of sleek hunters roaming the back alleys of the modern city. He was of course guaranteed an audience by the growing number of pet owners in Japan, as well as from overseas.

TOKURIKI Tomikichirō　徳力富吉郎
1902-1999

Born in Kyoto to a family of artists dating to the 17th century, and educated in Japanese-style painting. Started making woodblock prints in 1929, studying with a printer from the *ukiyo-e* traditon, and became a key figure among print artists in Kyoto. Member Nihon Hanga Kyōkai. Published by Uchida and others before the war; created his own company to publish *sōsaku hanga* after the war. Divided his work into "artisan prints" and "creative prints." Statler observes, "For his artisan prints he has developed a colorful style with obvious sales appeal, and his reputation as a print artist in Japan rests largely on the several popular series of landscapes which have been a tidy source of profit to various Kyoto publishers." (121) Statler also notes that a print expert named Fujikake "has said that [Tokuriki's prints] suggest painting rather than woodblock, and Tokuriki agrees with him. 'I know that we adhere very closely to the brush stroke...Perhaps Kyoto print artists are too accomplished technically. We were never gripped by the same rebellion against *ukiyoe* technique that motivated the Tokyo artists...'" (121)

12 *New Eight Views of Omi*
Portfolio of eight woodblock prints
Portfolio 15 1/2 x 13 5/8"
All prints 11 1/8 x 9 3/4" (image)
Gift of Dr. Leo and Mary Corazza
BAM2002.033

A set of "artisan prints," this album includes a paper insert that reads, "Engraved and Printed by Uchida Woodblock Printer, Takakura, Takeyamachi Street, Kyoto, Japan." Gives titles in Japanese and English. Descriptive text associates Tokuriki with such artists as Kawase Hasui, Itō Shinsui, and Yoshida Hiroshi. This text also notes that "A woodblock print cannot be made in other country excepting Japan [sic]. A woodblock print cannot be finised [sic] thoroughly until the individual talent of an original painter, carver and printer are combined into one purpose by their artistic spirit." The text associates Tokuriki with the "traditional" style of printmaking, practiced at the time by artists associated with the shin hanga movement, and opposed by those working in the manner of *sōsaku hanga*.

The places are real attractions clustered around Japan's largest body of fresh water, Lake Biwa, and are depicted with a clear realism tinged only slightly with sentimentality. The results link with ancient traditions of envisioning poetic sites in Japan and China, such as the "Eight Views of the Xiao and Xiang Rivers," a collection of poems from the tenth century translated into ink paintings from the eleventh century onward across East Asia.

12a *Yabashiri in Early Spring*
矢走の早春 (*Yabashiri no sōshun*)

12b *Evening Scene of Hama-Otsu*
浜大津夕景 (*Hama Ōtsu yūkei*)

12c *The Full Moon of Ishiyama Temple*
石山寺名月 (*Ishiyamadera meigetsu*)

12d **Mt. Hira Covered with Evening Snow**
比良山暮雪 (Hirasan bosetsu)

12e **Lake Biwa Viewed at Miidera Temple**
三井寺より湖水望む (Miidera yori kosui nozomu)

12f **The Pine-Trees of Shinkarasaki**
新唐崎の松 (Shinkarasaki no matsu)

12g **Katata Ukimido Temple**
堅田浮御堂 (Katata Ukimidō)

12h **Shirahige Shrine**
白鬚の社 (Shirahige no yashiro)

SAITŌ Kiyoshi 斉藤清
1907-1999

Born in Sakamoto, Fukushima Prefecture. Learned sign painting as a child. Around 1932 moved to Tokyo, where he studied and exhibited Western-style oil paintings. Became interested in making woodblock prints from a single block that he carved and printed progressively. While working at the newspaper *Asahi Shinbun* met Onchi Kōshirō and became a member of Nihon Hanga Kyōkai and Kokugakai. Beginning with exhibitions in a gallery next to the Imperial Hotel, his work drew the attention of Americans, among whom it became very popular. Was one of the first Japanese print artists to achieve international recognition. U.S. State Department and Asia Foundation sponsored his trip to the U.S. in 1956, resulting in even greater popularity among Americans. Merritt notes that he "was attracted to the use of wood grain in the work of Gauguin and Munch in the 1940's. In 1954 on a visit to Katsura palace in Kyoto he discovered the orderly beauty of architecture and compared it to the intellectual organization he had seen in Mondrian paintings. This led him to search for the essentials of nature and express them in flat areas of color and texture in bold and graceful designs." (129)

Saitō seems to have been astute at promotion of the *sōsaku hanga* movement, and of his own work. His signature is usually found in the image, not in the margin. And many of his prints, sometimes made with paper watermarked with his name, have a slip of paper glued to the back with the inscription, "Self-carved Self-printed Kiyoshi Saito." This phrase is in essence the motto of the *sōsaku hanga* movement.

Although some of Saitō's images can be taken as catering to Orientalist fantasies (ranging from serenely meditative Buddhas to a stylized representation of an enigmatic Egyptian), it cannot be denied that he found an unusual combination of popularity and aesthetic rigor in his geometric images of Japanese gardens and architecture.

13 **Sleeping Dachshund**
Woodblock print, 1954
Numbered 70/80
15 1/4 x 20 7/8" (image)
Promised gift of the Philip and Muriel Berman Foundation
BAM1988.56L
Provenance: R. Snyder Collection, New York (October 1965)

Untitled recto; "Sleeping Dachshund" in pencil verso.
Signed "Kiyoshi Saito" in pencil on image.
Seal above signature. Seal verso.

Saitō produced a series of animal prints early in his career; the Berman Collection includes another of a seated dachshund, probably drawn from the same model. "Sleeping" in the title comes from the Japanese *neru*; given the open, alert eyes, we should probably interpret it as "lying down" or "recumbent."

14 **Syoji Katsura Kyoto (A)**
Woodblock print, 1954
Numbered 49/50
10 7/8 x 27 7/8" (image)
Promised gift of the Philip and Muriel Berman Foundation
UC1989.1.068

Singed in pencil on print, "Kiyoshi Saito." Red seal above signature. Label attached recto: "Self-carved self printed KIYOSHI SAITO." Seal on label.

Three prints in the exhibition were inspired by the seven-teenth-century *shoin* style residences in and around Kyoto. Saitō here concentrates on *shōji*, the flat screens with translucent paper stretched across them that separate interior and exterior space at the Katsura Imperial Villa. The structure, built in the seventeenth century by Prince Toshihito (1579-1629) and his son Toshitada (1619-1662), led modernist architect Bruno Taut, in an often-quoted essay, to comment on the modernity and perfection of the structures at Katsura; Saitō's vision of flat, geometric spaces is almost as much an homage to the Bauhaus style as to the actual buildings. He returned to the walkways of Katsura for the image in Print 16, and to the bridges and streams in the garden of another Imperial residence, the Sentō Gosho (Immortal's Grotto Palace, designed by Kobori Enshū in 1634) for the image in 22.

15 **Chinese Temple Nagasaki**
Woodblock print, 1955
Numbered 37/40
20 1/4 x 32" (image)
Promised gift of the Philip and Muriel Berman Foundation
BAM 1988.161L

Also known as "Japanese Temple Nagasaki." Signed "Kiyoshi Saito" in pencil on print, with seal above. Paper label attached verso as in 14. Seal on label.

This "Chinese" temple in Nagasaki is probably 興福寺 (Kōfukuji), established in 1620 as the first temple of the Ōbaku sect of Zen Buddhism.

This print is particularly noteworthy for its depiction of the heavy tiled roofs of the temple. The arrangement of these massive forms provides a strong sense of space, in contrast to the extreme flatness of such later prints as flatness of such prints as "Syoji Katsura Kyoto (A)" The subtle colors give a sense of peace, and the heaviness of the roofs seems oddly reassuring, especially as it is relieved by the white space at the center, which provides an orientation point of human-scaled space.

16 *Katsura Kyoto*
Woodblock print, 1955
Numbered 53/150
15 1/4 x 20 7/8" (image)
Promised gift of the Philip and Muriel Berman Foundation
BAM1988.60L
Provenance: R. Snyder Collection, New York (October 1965)

Signed on image "Kiyoshi Saito," with seal above.

17 *Mansion*
Woodblock print, 1955
Numbered 16/50
20 1/8 x 32" (image)
Promised gift of the Philip and Muriel Berman Foundation
BAM1988.160L

Signed "Kiyoshi Saito" on image with seal above.
"Self-carved" label attached verso, as in 14.

Title given on print as "Yakata" in romanization, here
translated as "Mansion." This term can also be translated as
"castle," but building style contradicts such an identification
in this case. Nevertheless, the title "Castles" is written in
pencil verso.

18 *Buddha Miroku*
Woodblock print, 1957
Numbered 26/100
29 5/8 x 16 1/2" (image)
Promised gift of the Philip and Muriel Berman Foundation
BAM1988.51L

Signed "Kiyoshi Saito" in pencil on image. Seal above.
"Self-carved" label (see 14) attached verso, with seal.

The elongated images of the Asuka era in the seventh
century are emulated in this image of the Buddha of the
Future, seen in a pose of contemplation. No single image,
such as the wooden sculptures of Kōryūji or Chūgūji, is the
direct inspiration for this piece, though the attenuated form
and pensive posture can be traced to such roots. The wood
grain of the background further accentuates the slender
body of the image.

19 *Clay Image (S)*
Woodblock print, 1957
Numbered 6/100
15 1/4 x 20 7/8" (image)
Promised gift of the Philip and Muriel Berman Foundation
BAM1988.155L
Provenance: R. Snyder Collection, New York (October 1965)

Signed "Kiyoshi Saito" on image in white ink.
"Self-carved" label attached verso, with seal.

Here Saitō looks to the ancient Japanese practice of
decorating mound tombs with clay images (*haniwa*) with
simple, masklike facial forms. The mysterious power of
these figures, part guardian, part attendant for the
deceased chief, is strongly evoked by the bold forms of
the printed images.

20 *Egypt*
Woodblock print, 1957
Numbered 3/80
29 3/4 x 17 5/8" (image)
Promised gift of the Philip and Muriel Berman Foundation
BAM1988.50L

Signed "Kiyoshi Saito" on image in white ink.
Title given as "Egyptian" in pencil verso.

By looking to ancient cultures, Saitō explored the power their
images continue to hold in the modern world. His figure is
boldly androgynous, with the false beard reflecting the actual
practice of such female rulers as Queen Hatshepsut of the
18th Dynasty, who lived more than four thousand years
ago. By placing symbolic male hair on their faces, rulers
emphasized their authority with a clear visual symbol.
Saitō's interest is, however, as much in the mysterious form
as in the political implications of a distant past.

21 *Moss Garden Saiho-ji Kyoto*
Woodblock print, 1957
Numbered 20/80
17 3/4 x 23 5/8" (image)
Gift of Philip and Muriel Berman
UC1989.6.006
Provenance: R. Snyder Collection, New York (March 1968)

Signed "Kiyoshi Saito" in pencil on image. Seal above.
"Self-carved" label (see 14) verso, with seal.

On the site of Saihōji, in the southwestern suburbs of
Kyoto, Buddhist temples have been operating since the
eighth century, but the garden was laid out around 1339
by an important Zen priest, Musō Soseki (1275-1331). The
walkways have been reconstructed after damage by
earthquakes, but still wind delightfully around dark ponds
and between lichen-covered trees. Most of the garden,
however, is covered by lush *sugigoke* cedar moss, providing
a popular alternative name for the temple, Kokedera, the
Moss Temple.

22 *Garden Sendogosyo Kyoto*
Woodblock print, 1958
Numbered 21/70
17 5/8 x 24" (image)
Promised gift of the Philip and Muriel Berman Foundation
BAM1988.159L
Provenance: R. Snyder Collection, New York (October 1965)

Signed "Kiyoshi Saito" in pencil on image. Seal above.
"Self-carved" (see 14) label verso, with seal.
Paper watermarked "KIYOSHI SAITO."

23 *Silent Prayer*
Woodblock print, 1958
Numbered 11/30
20 1/2 x 15 3/4" (image)
Promised gift of the Philip and Muriel Berman Foundation
BAM1988.53L

Untitled recto. Title verso in pencil as 黙祷 (*mokutō* or "silent prayer") in what appears to be artist's hand. Also known as "Buddhist." Seal recto on image. Signed "Kiyoshi Saito" in margin, along with inscription "TO MRS. OWEN 1958." Inscribed verso 贈ミセス・オーエン (To Mrs. Owen) and signed 斉藤清. Dated January 1958.

This image of the head of a *bodhisattva*, a being as enlightened as any Buddha but still active in the world, evokes spiritual power and artistic tradition. The form is that of a Chinese image from the Sui period (580-618), fragmentary yet solid against the dark background, calm in resolute spirit yet decorated with carved jewelry and white face paint.

24 *Bunraku (B)*
Woodblock print, 1959
Numbered 12/100
20 3/4 x 15 1/8" (image)
Promised gift of the Philip and Muriel Berman Foundation
BAM1988.153L

Signed "Kiyoshi Saito" in white ink on image. Seal above. Paper watermarked "KIYOSHI SAITO."

A dramatic representation of the head of a puppet from the Japanese *bunraku* (puppet) theater. The movement and expression of the head is controlled by levers, not shown here, at the bottom of the stick. When dressed, the puppet is approximately half the size of a person. Saitō is adept at conveying an uncanny lifelike feeling in his representations of dolls and sculpture.

25 *Shoji Sanpo-in Kyoto*
Woodblock print, 1960
Numbered 130/150
15 3/8 x 20 7/8" (image)
Gift of Philip and Muriel Berman
UC1989.1.069
Provenance: R. Snyder Collection, New York (March 1968)

Signed "Kiyoshi Saito" in white ink on image. Seal above. "Self-carved" label (see 14) attached verso, with seal. Paper watermarked "KIYOSHI SAITO."

Sanpōin is a subsidiary temple to Daigōji, located in the eastern hills of Kyoto. The temple was founded in 1115 and rebuilt by Toyotomi Hideyoshi in 1598 after it was destroyed in a fire. The temple houses important paintings, along with a garden said to have been designed by Hideyoshi.

Saitō's citation of the *shōji*, or sliding paper screens, seems to be linked to his study of Mondrian; both artists exhibited an interest in reducing architecture and landscape to simple geometric forms. The two-dimensionality of this print is particularly striking, and its artificiality is heightened by the appearance of a strong wood grain.

26 *Syoren-in Kyoto*
Woodblock print, 1973
Numbered 17/100
20 3/4 x 15 1/8" (image)
Gift of Philip and Muriel Berman
UC1989.4.016

Signed "Kiyoshi Saito" in black ink on image. Red seal above. "Self-carved" label (see 14) attached verso. Paper watermarked "KIYOSHI SAITO."

Usually romanized as "Shōren-in" (青蓮院), this is a temple of the Tendai sect, and one of five such temples associated with the imperial family.

UENO Makoto　上野誠
1909-1980

Born to the Uchimura family in Kawanakajima, Nagano Prefecture. Adopted his wife's family name of Ueno. While studying to be a teacher in art school, was arrested for communist activities. Studied woodblock printmaking with Hiratsuka Un'ichi while working in a factory. Became influenced by prints of Kathe Kollwitz. Member Nihon Hanga Kyōkai and exhibited with Kokugakai. Was actively engaged with artists in China and Russia.

27 *Matsumoto Castle*
Woodblock print, 1973
Numbered 19/50
21 7/8 x 15" (image)
Gift of Dr. Leo and Mary Corazza

Signed in kanji only: 上野誠. Title given in Japanese only as 松本城 (Matsumoto jō).

Matsumoto Castle, located in Ueno's home prefecture, is one of the very few major Japanese castles to have largely survived the ravages of history, including the near total destruction of most of Japan's large cities during World War II. Its grandeur is implicitly compared with the majesty of the Japan Alps. This truncated image makes use of the clean lines of the massing of the castle, in much the way that the director Kurosawa Akira used Himeji Castle in such films as "Kagemusha." This print combines a strong design with an emotional tie to its subject.

TAJIMA Hiroyuki　田嶋宏行
1911-1984

Born in Tokyo; studied Western painting at Tokyo School of Fine Arts. Influenced by dada and surrealism. Merritt notes that he "joined Bijutsu Bunka Kyōkai in 1946, a group instrumental in bringing back abstract and surrealist painting suppressed during World War II." Member Nihon Hanga Kyōkai. According to Merritt and Yamada, in late works Tajima "used shellac, torn paper, dyes, and other materials in conjunction with woodblocks for low-relief printing of complex textures in sonorous colors." (141) "Epitaph A" provides a good example of this style.

28 *Epitaph A*
Woodblock print, 1964
Numbered 20-1 [1/20]
24 x 18" (image)
Gift of Philip and Muriel Berman
UC1989.6.005
Provenance: R. Snyder Collection, New York (March 1968)

Title given recto in both Japanese 碑銘 A (*himei* A) and English. Signed "Hiroyuki Tajima."

29 *Impression of a Tea-room*
Woodblock print, 1968
Numbered 80-20 [20/80]
23 1/8 x 17 7/8" (image)
Gift of Dr. Leo and Mary Corazza

Title given in both English and Japanese 茶屋の印象 (*chaya no inshō*). Signed "Hiroyuki Tajima."

Tajima employs two very different styles in his three prints in the exhibition. The heavy, metallic forms of *Epitaph A* and *Pierrot and his Son* draw on sources in European expressionist art of the twentieth century. Both the title of the latter and the bold abstraction of its forms may be linked to works by Picasso, but the tonal harmony evokes Paul Klee as well. *Impression of a Tea-room*, by contrast, is lighter, more organic, and much more representational. The creative edge here is perhaps strongest in the shifting of the viewpoint to within the tea-room, as perceived by a guest at a performance of ritual tea, rather than merely by a casual tourist looking at the exterior.

30 *Pierrot and His Son*
Woodblock print, 1970
Numbered 50-12 [12/50]
22 1/4 x 16 7/8" (image)
Gift of Dr. Leo and Mary Corazza

Title given in English and Japanese 道化子とそのむすこ (*dōkeshi to sono musuko*). Signed "Hiroyuki Tajima."

YOSHIDA Tōshi 吉田遠志
1911-1995

Born in Tokyo. Studied woodblock printmaking with his father, the *shin hanga* artist Yoshida Hiroshi, who, unlike other artists of his movement, had learned the techniques of carving and printing. Traveled extensively throughout the world. Member Nihon Hanga Kyōkai. Worked in both figurative and abstract styles.

31 *Three*
Woodblock print, 1970.
Numbered 1/150
22 1/2 x 15 3/4" (image)
Promised gift of the Philip and Muriel Berman Foundation
BAM1988.164L
Provenance: 38th Japan Print Association Exhibition, Tokyo (April 1970)

Signed "Toshi Yoshida."

Three is a symbolic number in Buddhist as well as Christian art, but Yoshida's forms evoke neither in any specific way. Instead, they seem to be whirlpools, or perhaps whirlwinds, floating in a stippled sky. He used similarly spiraling forms in a number of other prints from the same period in the late 1960's and early 1970's.

HAGIWARA Hideo 萩原秀雄
1913-

Born in Kōfu, Yamanashi Prefecture. Studied with Hiratsuka Un'ichi at the Tokyo School of Fine Arts. Began to make prints while ill with tuberculosis after the war. Most noted for abstract prints, produced starting in 1958. Member Nihon Hanga Kyōkai, and winner of awards at international competitions. Taught at University of Oregon in 1967. Merritt and Yamada note that he "visualizes ideas and then carves directly and spontaneously without preliminary sketches." (25) Often prints on back of paper to enhance image on front.

32 *Milky Way*
Woodblock print, 1959
Numbered 10/30
15 1/4 x 11 1/4" (image)
Gift of Philip and Muriel Berman
UC1989.1.070
Provenance: R. Snyder Collection, New York (March 1968)

Title given in Japanese 銀河 (*ginga*) and English. Signed "Hideo Hagiwara."

The rice paper used for this print is much thinner than that used in most other prints in this exhibition. The image is almost translucent, and is more drawing-like than those of typical prints. The title is written in Japanese on the print as 銀河 (*ginga*) literally, "Silver River," one of the Japanese terms for "Milky Way."

WATANABE Sadao 渡辺楨雄
1913-1996

Born in Tokyo. Baptized as a Christian in 1930. Studied *katazome* (stencil printing) with Yanagi Sōetsu and Serizawa Keisuke, two leaders of the *mingei* (folk art) movement. Made several visits to the U.S., where he taught printmaking in Oregon and Minnesota. All of his subject matter is taken from the Bible.

Achieves his distinctive effect using *momigami*, hand-crumpled mulberry paper. The images in his prints combine the influence of early Christian iconography with the *mingei* style of stencil printing.

33 *Noah's Ark*
Stencil print on mulberry paper, 1978
Numbered 88/100
21 x 18" (image)
Promised gift of the Philip and Muriel Berman Foundation
BAM1989.126L
Provenance: From the artist; The Red Lantern Shop, Kyoto

Signed in black ink "Sadao Watanabe."

34 *Jonah and the Whale*
Stencil print on mulberry paper, 1979
Numbered 14/80
20 1/2 x 17 3/8" (image)
Promised gift of the Philip and Muriel Berman Foundation
BAM1989.120L

Provenance: From the artist; The Red Lantern Shop, Kyoto

Signed in white ink "Sadao Watanabe."

35 *Lazarus the Beggar*
Stencil print on mulberry paper, ca.1977
Numbered 15/80
20 x 17 1/2" (image)
Promised gift of the Philip and Muriel Berman Foundation
BAM1989.122L
Provenance: From the artist (June 1980); The Red Lantern Shop, Kyoto

Signed in white ink "Sadao Watanabe."

Watanabe is the only strongly Christian artist represented in this show, his conversion symbolized by his illustration of Bible stories in nearly every print in his large oeuvre. By combining these traditional tales with a *mingei* style based on folk-art traditions in stamped and dyed fabric decoration he creates a simple yet beautiful atmosphere of innocent belief and naïve faith.

SEKINO Jun'ichirō 関野準一郎
1914-1988

Born in Aomori. Started making woodblock prints in middle school. Member Nihon Hanga Kyōkai and Kokugakai. Studied etching and painting, and studied printmaking with Onchi Kōshirō and Maekawa Senpan. Well-known in the U.S. for his prints, he traveled to America and taught in 1963 at Oregon State University. Earlier works centered on portraits; abstractions predominate during later years.

36 *Girl in Kimono*
Woodblock print, 1958
Numbered 38/100
24 1/4 x 18 3/4" (image)
Promised gift of the Philip and Muriel Berman Foundation
BAM1988.163L

Title handwritten, probably not by artist, in pencil at bottom: "Girl in Kimono." Also known as "Japanese Girl in Kimono" and "My Daughter."

Signed "Jun. Sekino" in white ink on image. Stamped in bottom margin: "Self-carved self-printed Jun-ichiro Sekino."

KITAOKA Fumio 北岡文雄
1918-

Born in Tokyo, and studied Western painting at Tokyo School of Fine Arts. Studied woodblock printmaking with Hiratsuka Un'ichi. Worked in Manchuria in 1945-46, when he became influenced by Chinese social realist prints. Back in Tokyo, he was a member of Onchi Kōshirō's circle. Member of Nihon Hanga Kyōkai. Studied in France in the 1950's, and taught at art schools in the U.S. Merritt and Yamada note that "after passing through realistic and abstract stages, Kitaoka's mature style embraces both realistic representation and abstraction in carefully designed and often brightly colored landscapes." (69)

37 *Snow Scene*
Woodblock print, 1969
Numbered 16/50
21 1/2 x 15 3/4" (image)
Gift of Dr. Leo and Mary Corazza
BAM2002.032

Title given in both Japanese 雪景 (*sekkei*) and English. Signed "Fumio Kitaoka."

An excellent example of the "mature" style described by Merritt and Yamada, this print creates a complex sense of space by combining flat and modeled elements, and then bursting into expressionistic abstraction in the swirling forms in the lower right.

38 *Tea Stall at Miidera*
Woodblock print, 1970
Numbered 16/100
15 3/4 x 21 5/8" (image)
Gift of Philip and Muriel Berman
UC1989.6.052
Provenance: 38th Japan Print Association Exhibition (April 1970)

Title given in both Japanese 三井寺の茶店 (*Miidera no chamise*) and English. Signed "Fumio Kitaoka."

What would be a timeless scene, presented in a style reminiscent of folk art (*mingei*), of the area at the entrance of one of Japan's most famous temples is updated by figures in "modern" dress, along with such elements as a sign advertising "Fujicolor" film. The monochromatic representation of the fountain for ritual cleansing is cheered up by the colorful stickers left by pilgrimage groups.

IKEDA Shūzō 池田修三
1922-

Born in Kisakata, in Akita Prefecture. located in the far north of Honshū island. After teaching in Akita for many years, moved to Tokyo to work as an artist. Member of Nihon Hanga Kyōkai. Merritt and Yamada observe that "he frequently depicted stylized large-eyed women or children with birds, flowers, insects, sacred stone images, or native dolls." (40)

39 *Wild Chrysanthemums*
Woodblock print, 1965
Numbered 4/70
16 1/2 x 11 1/2" (image)
Gift of Philip and Muriel Berman
UC1989.1.072
Provenance: R. Snyder Collection, New York (March 1968)

Title given in Japanese only as 野菊 (*nogiku*), which can be translated as "wild chrysanthemum" or "aster." Signed "Shuzo Ikeda" in white ink on image.

This image appears at first to be rather simplistic and "cute," but upon a closer look one notes that the head evokes the *haniwa* hollow clay tomb figurines (19) while also taking a shape reminiscent of the large round head of the

bodhisattva Jizō. However, the hand gesture (*mudra*) is one associated with the Buddha, and indeed, the holding of the flower reminds the viewer of the story about how the Buddha, in response to a question as to the nature of the universe, replied by silently grasping a single flower.

Although the image may be said to be less sophisticated than many of the others (Hello Kitty or Walter Keane come to mind), it appears that the artist wishes to convey a simple, appealing message of peace and compassion.

USHIKU Kenji 牛玖健治
1922-

Born in Chiba Prefecture. Studied Western painting and sculpture at Tokyo School of Fine Arts. Member Nihon Hanga Kyōkai. Made woodblock prints, but most noted for etchings.

40 *Mountain God, Sea God*
Color intaglio print, undated
Numbered 15/80
16 1/2 x 8 7/8" (image)
Gift of Dr. Leo and Mary Corazza

The title is written in Japanese only: 山の神、海の神 (*yama no kami, umi no kami*). Signed "Kenji Ushiku."

Though his forms are purely abstract, the conflicting energies of the mountain god and the sea deity are symbolized in the red, brown, and green colors of this work. The title (and concept) may reflect the ancient legend of two brothers, one of whom chooses the mountains for his home and the other a life of fishing, and the inevitable tragedy when they try to exchange places.

KINOSHITA Tomio 木下富雄
1923-

Born in Yokka-ichi, Mie Prefecture. Early prints depicted local scenery, in a style influenced by Hiratsuka Un'ichi. Member Nihon Hanga Kyōkai and Kokugakai. Exhibited in Philadelphia International Prints Exhibition in 1963. "In his mature style he developed images of highly abstracted heads composed of characteristic jagged lines." (Merrit and Yamada, 67)

41 *Masks (I)*
Woodblock print, 1950
Numbered 11/50
35 5/8 x 23 7/8" (image)
Promised gift of the Philip and Muriel Berman Foundation
BAM 1988.162L
Provenance: Yōseidō Gallery, Tokyo

Reproduced in Petit, v.1, b/w plate no.105, as "Mask (1)."

Title given only in Japanese as 仮面たち (I) (*kamentachi*). Signed "Tomio Kinoshita."

This image, of heads that appear to have been carved from blocks of wood, is striking in the power of its primitive and archetypal quality. There is something at once strong and mournful about these heads, which seem to be engaged in

a kind of silent dialogue. Michener quotes Kinoshita on a similar print: "In combinations of faces…I am trying to express the sufferings of society, of man, of mankind, of all living beings." (34) This sentiment is not surprising, coming only five years after a war of unimaginable devastation. The masks all face in different directions – the future will take many forms – but they share a sense of empathy and perseverance.

YOSHIDA Chizuko 吉田千鶴子
1924-

Born in Yokohama, and educated at the Women's Specialist School of Fine Arts. Studied woodblock printmaking with Kitaoka Fumio. Married Yoshida Hodaka in 1954 after appearing with him in a two-person exhibition. Member Nihon Hanga Kyōkai. Cofounded Women's Print Association (Joryū Hanga Kyōkai) with Iwami Reika. Traveled in US, Europe and Asia in 1957-58. Abstraction dominates works of early 1960's, after which prints began to include images of butterflies, flowers and shells.

42 *Into the White Strata*
Relief screenprint with photoengraving, 1971
Numbered 2/50
28 1/2 x 20" (image)
Gift of Dr. Leo and Mary Corazza

Titled only in Japanese, as 白い層の中え (*shiroi sō no naka e*). Signed "Chizuko Yoshida."

This image is representative of the popularity of the incorporation of photographic images in art and graphic design of this era. The image is rather sensual (if not feminist) and perhaps a bit psychedelic.

MAKI Haku 巻白
1924-2000

Born in Ibaraki Prefecture as Maejima Tadaaki. Learned printmaking in the circle surrounding Onchi Kōshirō. Member Nihon Hanga Kyōkai. In early work used wire brushes and other tools to experiment with natural wood grain. In later work, including works in this exhibition, Maki used dental cement to build up relief on wood and cardboard. Noted for his highly embossed prints, often of pottery, or incorporating calligraphy.

43 *Poem 68-16*
Woodblock print, 1968
Numbered 45/71
11 5/8 x 5" (image)
Gift of Dr. Leo and Mary Corazza

Signed "Haku Maki." Seal on image.

44 *Poem 69-43*
Woodblock print, 1969
Numbered 43/201
7 3/4 x 5 1/2" (image)
Gift of Dr. Leo and Mary Corazza
Signed "Haku Maki." Seal on image.

45 *Poem 70-8 (Woman)*
Woodblock print, 1970
Numbered 42/157
22 3/8 x 15 3/4" (image)
Promised gift of the Philip and Muriel Berman Foundation
BAM1988.154L
Provenance: 38th Japan Print Association Exhibition
(April 1970)

Title given as "Poem 70-8 (女) (onna).
Signed "Haku Maki." Seal on image.

The red image is a slightly stylized rendition of the Chinese
character for woman, as given in the title. In referring to a
similar work, Maki said that he had "tried to give our cultural
heritage of such ideographs a modern feel, but in an
Oriental style." (Michener 54)

46 *Work 74-95*
Woodblock print, 1974
Numbered 108/203
8 3/4 x 8 3/4" (image)
Gift of Dr. Leo and Mary Corazza
Provenance: The Red Lantern Shop, Kyoto (1975)

Signed "Haku Maki." Seal on image.

In the "Poem" and "Works" prints, Maki derives his image
from ancient forms of the Chinese characters used for
writing Japanese. Working on blocks embellished with
wax, cement, or even concrete, he produces an embossed
pattern enhanced with deeply saturated areas of red, blue,
and black.

47 *Collection 35*
Woodblock print, undated
Numbered 40/160
9 1/4 x 8" (image)
Gift of Dr. Leo and Mary Corazza
Provenance: The Red Lantern Shop, Kyoto

Signed "Haku Maki." Seal on image.

Maki stepped away from the literary inspirations of his
earlier prints in the "Collection" series and began to
re-create the forms of ceramic vessels such as tea bowls
and saké bottles. The stark contrast between the pure white
(or black) background and the embossed black (or white)
bowl is a study in harmonized opposites with a tactile edge.
A real teabowl can only be appreciated by holding it, and
Maki makes the viewer long to pluck these vessels from the
paper and try them out with a beverage!

48 *Animal Song – Dog*
Woodblock print, undated
Numbered 14/50
14 7/8 x 14 7/8" (image)
Gift of Dr. Leo and Mary Corazza

Title given as "Animal Song 一戌 (inu). The kanji character
is the one used for "dog" in the Chinese calendar.
Signed "Haku Maki." Seal on image.

The image appears to incorporate the kanji character 吠,
which means "bark" or "howl." Maki may have been
referring to 「月に吠える」 (tsuki ni hoeru), or *Howling at
the Moon* (1917), a famous book of poems by Hagiwara
Sakutarō (1886-1942).

49 *Collection 3*
Woodblock print, undated
Numbered 175/203
5 x 5" (image)
Gift of Dr. Leo and Mary Corazza

Signed "Haku Maki." Seal on image.

IWAMI Reika　岩見礼花
1927-

Born in Tokyo. Influenced by Onchi. Attended classes taught
by Sekino. Member Nihon Hanga Kyōkai, and exhibited with
Kokugakai. Founding member, with Yoshida Chizuko, of
Joryū Hanga Kyōkai, an association of women printmakers.
Merritt and Yamada write that "her prints deal with elements
of nature – earth, water, fire, wind, sky – predominantly in
black and white with elegant use of gold leaf, embossing,
and impressions from driftwood she gathers from the beach
near her home in Kanagawa Prefecture." (48)

50 *Sea, Evening Calm*
Woodblock print, 1964
Numbered 135/210.
26 5/8 x 19 5/8" (image)
Gift of Dr. Leo and Mary Corazza

Signed "Reika Iwami."

Iwami's prints nearly always contain two elements –
pronounced wood grain effects and references to water.
Her work is starkly abstract, but the textural contrasts,
bold color areas, and curvilinear forms place her in the top
ranks of printmakers today.

YOSHIDA Hodaka　吉田穂高
1927-1995

Born in Tokyo. Father was Yoshida Hiroshi, the famous
and influential member of the *shin hanga* movement.
Member Nihon Hanga Kyōkai. Married to Yoshida Chizuko.
Traveled and exhibited extensively around the world, and
taught woodblock printmaking in 1957 at the universities
of Hawaii and Oregon, and at Haystack Mountain School
of Crafts. Early prints tended to be abstract; incorporated
photoengraving into later woodblocks.

51 *Enclosure <Village>*
Woodblock print, 1962
Numbered 4/50
29 1/4 x 14 7/8" (image)
Gift of Dr. Leo and Mary Corazza
Provenance: The Yōseidō Gallery, Tokyo

Title given only in Japanese: 廓<里> (kaku<sato>). Signed
"Hodaka Yoshida." Label verso identifies the print as "sōsaku

hanga" and notes that it is "self carved self printed." The artist is listed as "Yoshida, Hodaka" and the title is given as "Kuaku (Sato)." "*Kuaku*" (sometimes "*kwaku*") is an archaic romanization of "*kaku.*" The label is marked with the gallery name, "The Yoseido Gallery," and its address, "Nishi Ginza, Tokyo, Japan."

Although the print is abstract (there's a hint of Adolph Gottlieb in the round bursting image), the title directs the viewer to think about the significance of the Japanese village, which has been seen as a microcosm of and the foundation for Japanese society. The conservative nature of the village is reinforced by the regularly spaced circles that remind one of stones that hold up wooden pillars, or markings on a map. The burst of furious energy threatens to overwhelm the two wall-like images trying to suppress it. One may see in this print an acknowledgment of the turbulent 1960's, when economic growth and urbanization mark the beginning of a new paradigm for Japan. The sense of this transgressive energy is heightened by the fact that the kanji character for "enclosure" can also refer to a "red light district."

SHIBUYA Eiichi　渋谷栄一
1928-

Born in Hokkaido. Art major in college. Lived in France 1965-1966 and 1971-1972. Member Nihon Hanga Kyōkai. Most works are etchings of landscapes, especially of city scenes in a light style with some influence from "continental" artists such as Bernard Buffet.

52 *Carnival*
Hand-colored etching, undated
Numbered 8/30
23 1/2 x 14 1/4" (image)
Gift of Dr. Leo and Mary Corazza

Signed "Eiichi Shibuya." Brown paper tape is attached along the edges of the print. On the tape is written 「カーニバル」 (*kaanibaru*, or "carnival") along with the name of the artist in kanji.

Shibuya evokes the spirit of Carnival (the celebration we know as Mardi Gras) in Latin America with delicate figures that dance across pastel color patches. The figures were created by drawing through the coating on a copper plate, which is then treated with acid. The uncoated portions are eaten away, allowing ink to remain in them for transfer to the paper using a press. The colored forms were applied to the paper before running it through the press.

AMANO Kunihiro　天野邦弘
1929-

Born in Hirosaki, Aomori Prefecture. Self-taught in printmaking. Member Nihon Hanga Kyōkai and Kokugakai, and widely exhibited in international print biennales.

53 *Morning Moon (J)*
Woodblock print, 1961
Numbered 16/50
15 1/4 x 21 5/8" (image)

Gift of Philip and Muriel Berman
UC1989.2.055

Title given in Japanese only as 残月(J). "*Zangetsu*" literally means "remaining moon." Signed "K. Amano" in margin, and signed "K. Amano" in pencil on image. "Moon J" in pencil verso.

54 *Castle Gate II*
Woodblock print, 1966
Numbered 180/210
21 3/4 x 15 1/4" (image)
Gift of Dr. Leo and Mary Corazza

Title given only in Japanese at bottom of left margin: 城門II (*shiromon*). Signed "Kunihiro Amano." Signed in *kanji* at bottom of right margin.

Using metallic inks and hard forms, Amano creates a sense of secure separation in this "gate" while implying that more lies beyond. Using a similar palette in 53, he evokes the natural and poetic autumn image of geese passing across the moon, departing early on their migratory journey.

KUMAGAI Gorō　熊谷吾郎
1932-

Born in Hirosaki, Aomori Prefecture. Studied Western painting at Musashino College of Fine Arts in Tokyo. Member Nihon Hanga Kyōkai and Kokugakai. Style is mostly abstract.

55 *Our Generation*
Woodblock print, undated
Numbered 10/50
15 5/8 x 22 1/8
Gift of Philip and Muriel Berman
UC1989.4.018
Provenance: R. Snyder Collection, New York (March 1968).

Title given only in Japanese: われらの時代 (*warera no jidai*). Signed "G. Kumagai."

As with many abstract images, the artist poses a challenge to the viewer – find the link, for yourself, between the title and the forms. Whether he intends to invoke a classic piece of rock music (The Who's *My Generation*) or merely to make us consider how we are linked by age, the brittle vibration of his hard forms is full of powerful energies.

SORA Mitsuaki　空充秋
1933-

Born in Hiroshima; studied at Tama School of Fine Arts in Tokyo. Worked for Sears Roebuck in Tokyo; later traveled in Mexico and US. Merritt and Yamada note that prints "often depict strong interlocking organic or geometric shapes." (138)

56 *Song of the Forest*
Woodblock print, 1977
Numbered 8/80
21 1/2 x 15 1/4" (image)
Gift of Dr. Leo and Mary Corazza

Title given only in Japanese as 森のうた (*mori no uta*).
Signed "Sora."

Like many of the prints in this show, these abstract forms are linked to music and nature. Seeing the trees may be impossible in this melodic grove, but the pulsating forms and vibrating colors of 1970's vintage popular music – from psychedelic to disco – dance energetically through these woods.

INAGAKI Akemi　稲垣朱実
1933-

Born in Tokyo, and studied printmaking with Tajima Hiroyuki, among others, during the 1960's. Exhibited with Nihon Hanga Kyōkai and Kokugakai. Merritt and Yamada state that her "prints include stark depictions of elegant, simple motifs, often trees, against a light background of perhaps water or snow." (41)

57 *Reflection*
Woodblock print, 1971
Numbered 100-33 [33/100]
17 7/8 x 19 3/4" (image)
Gift of Dr. Leo and Mary Corazza

Title given as "Reflection 映" (*ei* or *hae*).
Signed "Akemi Inagaki."

In this quiet print, Inagaki's trees appear beside a still pool, and calm greens create a serenely natural atmosphere. Though lacking the abstract power of her mentor's prints (see 28-30 above), the gentle imagery has a delicate sweetness we might easily link to stereotypes of female creativity.

KIMURA Yoshiharu　木村義治
1934-

Born in Tokyo. Began his study of printmaking with Sasajima Kihei in 1954. Member Kokugakai. According to Merritt and Yamada, his "prints often depict owls and other birds in bright color." (66)

58 *Song of Birds*
Woodblock print, 1966
Numbered 12/50
24 5/8 x 14 7/8" (image)
Gift of Philip and Muriel Berman
UC1989.2.053
Provenance: R. Snyder Collection, New York (March 1968)

Title given recto in Japanese only, as 鳥の唄 (*tori no uta*).
"Song of Birds" in pencil verso. Signed "Yoshiharu Kimura" in black ink.

Interlocking forms work like a contrapuntal melody across these avian songbirds. We may not be able to recognize their species, but the glances of their eyes, sharp beaks, and smooth bodies of the forms, headed alternately left and right in their woven, stacked ovals, clearly evoke musical complexity.

KATAYAMA Mika　片山未加
1935-

59 *Red Parade*
Etching, undated
Numbered 12/30
14 x 2 1/2" (image)
Gift of Philip and Muriel Berman
UC1989.2.052

Born in Yokohama, Katayama works primarily in etching and related techniques such as drypoint. Her works are owned by the Fine Arts Museum of San Francisco, the Yokohama Shimin Gararii, and other institutions.

Untitled recto. Signed "M. Katayama."

As with the other etching in this show, Shibuya's *Carnival* (52), the stacking of etched forms and hand-colored shapes in this narrow gem of a print creates a lively dance along an urban parade route that we might link, visually, to the works of Paul Klee or Alexander Calder, among others.

KUSAKA Kenji　日下賢二
1936-

Born in Tsuyama, Okayama Prefecture. Member Nihon Hanga Kyōkai. Exhibited internationally in print biennales. According to Merritt and Yamada, his "early prints depicted objects in deep space. These were followed by boldly colored abstractions in which decorative dynamic movement is expressed through abstract forms and shapes in intense colors." (81)

60 *Work 71-14*
Woodblock print, 1971
Numbered 4/30
17 7/8 x 9 1/8" (image)
Gift of Dr. Leo and Mary Corazza

Title in Japanese only as 作品71-14 (*Sakuhin*).
Signed "Ken Kusaka."

Like the frequently-encountered modern "Untitled," as a designation for abstract works, the Japanese term *sakuhin* (literally "made piece" but normally translated "work") gives the viewer little in the way of a hint for interpreting the image, but this ambiguity opens the work to a wide range of meanings. Are those coffee beans floating on the brilliant yellow field? Should we link the lower section to the brand name (Rawlings) found on baseballs and other sports equipment? Perhaps the design is just that, a design, with the "bright colors and clear lines" of Leo Corazza's explicit aesthetic, and any meaning the viewer chooses to impart.

SHIMA Tamami　島珠実
1937-

Born in Hirosaki, Aomori Prefecture. Graduated from the Women's College of Fine Arts in Tokyo. Her prints of the 1960's "often feature rhythmic fanciful birds," according to Merritt and Yamada (135).

61 Bell Tower
Woodblock print, 1959
Numbered 34/100
21 x 15 1/4" (image)
Gift of Philip and Muriel Berman
UC1989.2.054

Title recto in Japanese only, as 鐘楼 (shōrō).
"Bell Tower" in pencil verso. Signed "Tamami Shima."

Although essentially geometric in form, this print still seems
a bit looser than similar prints made by Saitō and Hashimoto.
This can be seen especially in the trees and the roof of the
bell tower.

UNNO Mitsuhiro　海野光弘
1939-1979

Born in Shizuoka Prefecture. Self-taught in printmaking,
after an education in business. Associate member, Nihon
Hanga Kyōkai. Merritt and Yamada mention that noted as a
rural artist, his "works include unidealized representations of
country life." (163)

62 New Leaves on the Wayside
Woodblock print, 1971
Numbered 36/50
21 1/4 x 15" (image)
Gift of Dr. Leo and Mary Corazza

Carved into block are date and artist's given name:
1971.6.みつひろ. Title in margin in Japanese only,
as 路わかば (michi wakaba). Signed "M. Unno."

This portrayal of a quiet village, with two lonely figures
visible on the main street, is given an intense buzz by the
Day-Glo green framing the village scene. The "new leaves"
may provide a hint of an energy – and perhaps a hope for
the future – lying around and just beyond the placid, and
somewhat forbidding, hamlet.

TAKABE Taeko　高部多恵子
1941-

Born in Kanagawa Prefecture, she studied design in
college. Member Nihon Hanga Kyōkai. Art editor for
magazine Gunzō.

63 At Play in the Depths of the Sea
Lithograph with relief, undated (ca.1970?)
Numbered 14/30
7 1/8 x 23 3/4" (image)
Gift of Dr. Leo and Mary Corazza

Title given in Japanese only: 深海で遊ぶ
(shinkai de asobu). Signed "Taeko Takabe."

Using abstract forms based loosely on deep-sea fish and
other strange creatures, Takabe creates a playful setting
with this lithograph. This is the only print in our show created
with this method, in which a limestone slab is treated with
wax to create an image that can then be transferred to the
paper using inks and a press.

MARUYAMA Hiroshi　丸山浩司
1953-

Born in Tochigi Prefecture, and studied at the Tokyo
School of Fine Arts. Member of Nihon Hanga Kyōkai. Merritt
and Yamada write that his "prints of the 1970's featured
wide bands of deftly printed color undulating across dark
backgrounds." (85)

64 Round About Midnight No. 7
Woodblock print, 1977
Numbered 7/50
19 1/4 x 25 3/8" (image)
Gift of Dr. Leo and Mary Corazza

Signed "Hiroshi Maruyama."

The title of this print appears to be taken from the title
of Miles Davis' 1956 album, "'Round About Midnight,"
which features his version of Thelonious Monk's "'Round
Midnight." The stylized bands of color, forming two trumpet
bells, convey the intense, moody atmosphere of Miles
Davis. At the time the print was created, Japan (along with
Europe) was one of the cultures most appreciative of this
American music. Coffee houses featuring jazz played on
audiophile quality sound systems were a popular hangout
in the cities. Perhaps the most famous proprietor of a
jazu kissa was author Murakami Haruki.

LIST OF WORKS CONSULTED

Blakemore, Frances. *Who's Who in Modern Japanese Prints*. New York and Tokyo: Weatherhill, 1975.

Hiratsuka, Un'ichi. *Hiratsuka: Modern Master, From the Van Zelst Family Collection and the Art Institute of Chicago*. Chicago: The Art Institute of Chicago, 2001.

Kawakita, Michiaki. *Contemporary Japanese Prints*. tr. John Bester. Tokyo and Palo Alto: Kodansha International, 1967.

Keyes, Roger. *Break with the Past: The Japanese Creative Print Movement, 1910-1960*. San Francisco: The Fine Arts Museums of San Francisco, 1988.

Kindai Nihon hanga taikei. 3v. Tokyo: Mainichi Shinbunsha, 1975-1976.

Kuwayama, George. *Contemporary Japanese Prints*. Los Angeles: Los Angeles County Museum of Art, 1972.

Merritt, Helen. *Modern Japanese Woodblock Prints: The Early Years*. Honolulu: University of Hawaii Press, 1990.

Merritt, Helen and Nanako Yamada. *Guide to Modern Japanese Woodblock Prints: 1900-1975*. Honolulu: University of Hawaii Press, 1992.

Michener, James A. *The Modern Japanese Print: An Appreciation*. Rutland, Vt. and Tokyo: Charles E. Tuttle Co., 1968.

Petit, Gaston. *44 Modern Japanese Print Artists*. 2v. Tokyo and San Francisco: Kodansha International, 1973.

Smith, Lawrence. *Japanese Prints During the Allied Occupation, 1945-1952*. Chicago: Art Media Resources, 2002.

Smith, Lawrence. *Modern Japanese Prints 1912-1989: Woodblocks and Stencils*. London: British Museum Press, 1994.

Spangenberg, Kristin L. *Innovation and Tradition: Twentieth-Century Japanese Prints from the Howard and Caroline Porter Collection*. Cincinnati: Cincinnati Art Museum, 1990.

Statler, Oliver. *Modern Japanese Prints: An Art Reborn*. Rutland, Vt. and Tokyo: Charles E. Tuttle Co., 1956.

Tolman, Mary and Norman. *Collecting Modern Japanese Prints: Then & Now*. Rutland, Vt. and Tokyo: Charles E. Tuttle Co., 1994.

Watanabe, Sadao. *Printing the Word: The Art of Watanabe Sadao*. New York: American Bible Society, 2000.

INTERNET RESOURCES CONSULTED

www.artelino.com The site of an internet-based auction house for Japanese prints.

www.hangakyoukai.com The site of the Nihon Hanga Kyōkai (Japan Print Association).

www.yoseido.com The site of the Yōseidō Gallery, Tokyo, a major dealer in Japanese prints of all periods.